ALFREDO JAAR

MADELEINE GRYNSZTEJN

LA JOLLA MUSEUM
OF CONTEMPORARY ART

LA JOLLA MUSEUM OF CONTEMPORARY ART
La Jolla, California
January 14 - April 1, 1990

SAN JOSE MUSEUM OF ART
San Jose, California
May 6 - July 8, 1990

SEATTLE ART MUSEUM
Seattle, Washington
August 16 - September 30, 1990

CARNEGIE MELLON ART GALLERY
Pittsburgh, Pennsylvania
November 9, 1990 - January 20, 1991

LAUMEIER SCULPTURE PARK
St. Louis, Missouri
March 3 - May 18, 1991

THE NEW MUSEUM OF CONTEMPORARY ART
New York, New York
Fall 1991

This exhibition and catalogue have been made possible through the
generous support of Colette Carson Royston and Dr. Ivor Royston, the
Lannan Foundation, the Metropolitan Life Foundation, and a grant from
the National Endowment for the Arts, a federal agency which supports
the La Jolla Museum's "Parameters" series. This is the nineteenth exhibition
in the "Parameters" series.

Designed by Dennis Sopczynski
Typography by Central Graphics, San Diego
Printed by Rush Press, San Diego

Library of Congress Catalogue Card Number 89-63415
ISBN 0-934418-34-9

Cover:
Peters Map

CONTENTS

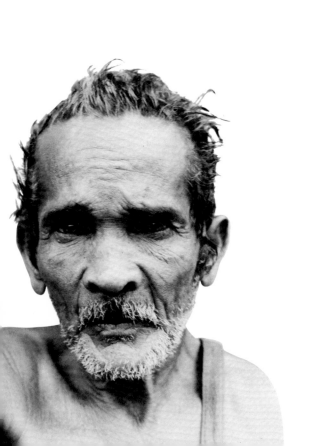

PREFACE

Chilean born, New York City resident Alfredo Jaar is at the forefront of a generation of artists who eschew art for art's sake, preferring to take as their subject the important economic, social, or political issues of our time. In both background and outlook Jaar is truly an international artist who lives his life in both hemispheres and makes work with the central theme of First and Third World interchange. At a moment when the Berlin Wall is being dismantled and East-West differences diminished, international attention will likely shift to the neglected North-South axis which has been Jaar's focus for many years. By example, the earliest piece in the exhibition, *Gold in the Morning*, chronicles the extraction of raw material from the Third World (Brazil) to be deposited in the First World, while his most recent research, *Geography = War*, investigates the dumping or depositing of western European hazardous waste in Nigeria.

After a decade of cynical Simulationists and angst-on-demand Neoexpressionists, Jaar's socially responsible themes and clear photographic formats are a welcome change. His decision to work without written texts sustains the powerful ambiguity of images which would otherwise be limited by the specificity of language. This sophisticated presentation draws equally from Minimalist art — the manufactured, modular, rectilinear container — and Madison Avenue — the big, ethereal, back-lit color photo, pushing a product so ingrained and elegant it's gone beyond words.

Jaar is deservedly one of the most closely watched and highly regarded artists working today and it is perhaps his privileged perspective on the underprivileged which accounts for his importance. The power of his work and message has demanded a larger audience and we are honored to have collaborated toward this end. Peruvian born Curator Madeleine Grynsztejn has brought the exhibition together with great precision and her introductory essay eloquently elucidates and contextualizes Jaar's contribution. Most of all we are grateful to Alfredo Jaar for his patience and friendship in creating this exhibition.

Hugh M. Davies
Director

Cries and Whispers, 1988 (detail)
light boxes with color transparencies
light boxes, 18" x 8' x 7" (2)
Courtesy the artist and Diane Brown Gallery,
New York

ACKNOWLEDGMENTS

Alfredo Jaar has been made possible by the enlightened interest and generous contributions of Colette Carson Royston and Dr. Ivor Royston, the Lannan Foundation, the Metropolitan Life Foundation, and a grant from the National Endowment for the Arts, a federal agency which supports the Museum's "Parameters" series. Their support of this exhibition and their recognition of its significance are acknowledged with profound appreciation.

I would like to thank those who have assisted me in the planning stages of the exhibition and in the securing of loans. Diane Brown, the artist's commercial representative, and the staff of the Diane Brown Gallery, especially Stephen Pelszynski and Cari Bryn Cohen, have readily and graciously responded to innumerable inquiries. Craig Cornelius was also instrumental in securing loans, as was Judith Calamandrei.

Among the numerous individuals who have advised me on Jaar's work, I would like to thank Sarah Bremser, Anna O'Cain, Greg Kahn, Leah Ollman, Allan Sekula, Elizabeth Sisco, Deborah Small, and Sally Stein. I owe a great debt of gratitude to Prudence Carlson for her thoughtful and illuminating insights on the artist's work as well as her encouragement, and to Tom Shapiro, who from the outset was an unfailing source of encouragement and support. This exhibition would have been impossible without the initiative and constant support of Hugh M. Davies, who also contributed essential and much valued advice. Curatorial decisions were aided by Lynda Forsha, whose advice and expertise were vital to the realization of this exhibition and catalogue. Marie Vickers Horne was primarily responsible for the painstakingly detailed biographic and bibliographic catalogue entries; she also skillfully, thoughtfully, and with good humor assisted with the production of the catalogue and the myriad clerical details inherent in such a project. Julie Dunn thoroughly reviewed and edited the entire catalogue text with her usual careful and considered judgment. The elegant graphic presentation of Jaar's art in this catalogue was intelligently carried out by Dennis Sopczynski, who oversaw the printing and production of the publication. Mary Johnson has my heartfelt thanks for her customary patience and deep commitment to the exhibition program; she has expertly guided me through many budgetary difficulties arising from loans, and has coped with the transport and insurance arrangements that this project entailed. Tom Flowers, Casey McLoughlin, William Bulkley, and Carlos Vasquez did an exemplary job installing Jaar's art here in La Jolla. Virtually all other museum staff members have played a role in this project, and I appreciate the help and encouragement of Norman Hannay, Anne Farrell, Diane Maxwell, Catena Bergevin, Janet Ciaffone, Tina Claridge, Gloria Jung, Mary Kristen, Mary McGroarty, Debra Palmer, and museum interns Robin Johnson, Kevin Muller, Veronica Sanchez, and Paz Tanjuaquio.

I am enormously grateful to the lenders who graciously parted with the works in their collections, and without whose generosity this exhibition could not have been realized. Particular thanks are due them for their extraordinary generosity in sharing their works with a wide audience for a long exhibition tour: the High Museum of Art; the Lannan Foundation; The Rivendell Collection; the Diane Brown Gallery; Richard Ekstract; Milton Fine; Emily Fisher Landau; Marsha Fogel; Lee and Sylvia Terry; and Sherry Remez Wagner and Ethan J. Wagner.

I salute the commitment to Jaar's work expressed by my colleagues at the five institutions that are sharing this exhibition with us: I. Michael Danoff, Director, and Colleen Vojvodich, Curator, the San Jose Museum of Art; Jay Gates, Director, and Patterson Sims, Curator of Modern Art, the Seattle Art Museum; Dr. Elaine A. King, Director, Carnegie Mellon Art Gallery; Dr. Beej Nierengarten-Smith, Director, and Blaine De St. Croix, Curator, Laumeier Sculpture Park; and Marcia Tucker, Director, France Morin, Senior Curator, and Laura Trippi, Curator, The New Museum of Contemporary Art.

Finally, my greatest gratitude is extended to Alfredo Jaar, who has collaborated on all aspects of the exhibition. He and his wife, Evelyne Meynard, graciously endured countless phone calls, meetings, and interviews. The artist has unstintingly given of his time and assisted me in innumerable ways. His intelligence and good nature have made the organization of this exhibition an intellectual and personal pleasure.

Madeleine Grynsztejn

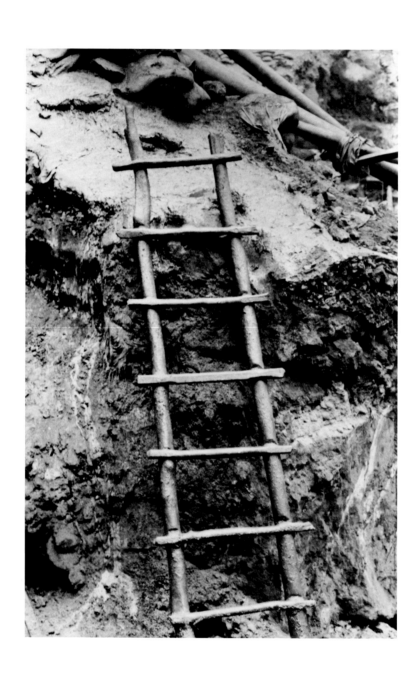

ILLUMINATING EXPOSURES:
THE ART OF ALFREDO JAAR

It may be true that one has to choose between ethics and
aesthetics, but it is no less true that, whichever one chooses, one
will always find the other at the end of the road. For the very
definition of the human condition is in the *mise en scène* itself.
Jean-Luc Godard[1]

There is a Third World in every First World, and vice-versa.
Trinh T. Minh-ha[2]

Alfredo Jaar's work, in its subject matter, media and *mise en
scène*, makes visible the inextricable links that tie the developed
or so-called "First World" to the less developed or so-called
"Third World," exposing the inequities which are endemic to
such power relations. Born and raised in Chile, witness to that
country's terrifying military coup, and now resident in New
York, Jaar possesses a unique insight into the formidable exercise
of power's authority and arrogance. For Jaar, the Third World
is an injurious misnomer: it is, to quote Shiva Naipaul, "an
artificial construction of the West"[3]— a term which blandly
subsumes the specific realities of countries as different and far-
flung as Brazil, Mexico, and Nigeria under a euphemism for
backwardness and exoticism. World events and the ever-
increasing political and socioeconomic connections between the
First and Third Worlds have made these once-convenient, still
pernicious terms obsolete. A more accurate, albeit rudimentary,
description of the world today, according to Jaar, might be that
there are different nations poised at different stages of develop-
ment, and in different areas of development.[4] Jaar's works have
rendered this new description through various means of expres-
sion, which since 1979 have ranged from found objects to
billboards to photo-text pieces. Yet his chosen medium has been
the photographic light box, usually a metal container housing
fluorescent tubes over which is fitted a photographic transpar-
ency. The images Jaar uses in these light box constructions are
immediate and topical documentations of current events: through
them we become witnesses to such global issues as the abuse of
human labor and natural resources in the Third World by
developed nations; the illegal immigration of Central and Latin
Americans into the United States; and the criminal dumping of
toxic wastes in Africa by Western industrialized countries.

These events are not recounted by Jaar in the manner to
which we have grown accustomed — that is, through the dry
generalizations of the mass media, the scientific "objectivity" of
anthropological discourse, or the indignant stance of the exposé.
Rather, the socioeconomic issues and global political events that
are Jaar's subject matter reveal themselves through individual
faces, introduced into the installations by way of the photo-
graphic light box. These are the faces of the "Other," those
racially and culturally different people of the Third World, living
at the perimeter of postindustrial production.[5] To the "flabby

Western concept"[6] of the Third World Jaar opposes flesh-and-blood people, and the specific realities that irrevocably tie these people's lives to ours, here and now. These are the people about whom we can say nothing that is not already suffused with our Western preconceptions and prejudices. Within his installations, Jaar formally underscores the impossibility of representing the people deemed Other in correct cultural terms, acknowledging in his asymmetrical compositions and unorthodox arrangements of elements the inherent flaw in any image we might fashion of the Other, given even our most conscientious attempts to avoid distortion. Yet Jaar also studiously avoids propagandizing about the economic injustices and cultural misreadings to which the people of the underdeveloped world are subjected. No accusatory text or soul-stirring appeal accompanies his installations. Indeed, his pieces attain an emotional and aesthetic weight precisely because the stance their maker assumes is an ambiguous one; Jaar's works suggest a newly complex position in which difficult political and cultural issues are never explained (away) by a simple summary of facts, statistics, or ideological program. The seeming opaqueness of Jaar's work allows the viewer the freedom and/or space to develop his or her own emotional response. Jaar's installations actively call upon independent critical awareness: such a summons becomes itself an act of social and cultural intervention, for it encourages the attitudes of vigilance and reform rather than of complacence and denial. Inherent in Jaar's installations, physically and thematically, is a critique which aims to provoke and reorganize the viewer's consciousness on a multitude of planes simultaneously—politically, geographically, psychoanalytically, ethically, aesthetically.

In Jaar's first major installation, **Gold in the Morning** (1986) (pp. 49-53), the First World and Third World meet in a remote northeast section of the Brazilian Amazon rain forest. There the hard labor and grueling living conditions, both concealed behind and supporting our high-tech postindustrial world, are endlessly carried out. Journalistic reports often provide the "story" or basis for Jaar's pieces, and in 1985 he read about and subsequently visited Serra Pelada (Naked Hill) to document in photographs and on video what has been described as the single richest gold find of this century. Serra Pelada was once a small mountain indistinguishable from thousands of others in the Brazilian rain forest; "discovered" in 1980, it is now Brazil's largest open-pit mine, a giant wound in the jungle a half-mile wide and hundreds of feet deep. This crater has been hewn out of the Amazon by *garimpeiros* (miners) using only hand tools such as picks, shovels, and sledgehammers to break up the rock in search of elusive veins of gold. During the peak season of April through November, 40,000 men live in the isolated mountain area; beneath the unvarying, mud-caked glaze that uniforms these workmen's bodies and faces is a diverse cross-section of Brazil — unemployed doctors from Rio de Janeiro, teachers, shopkeepers, farmers from the impoverished and drought-ridden northeast. In less than a year, 600 tons of dirt will be hauled out in 100-pound burlap sacks slung over the backs of these miners, who descend — perhaps forty times in one day — into the pit, negotiating the treacherous paths and ladders leading to and from the crest of the mine. Here, the dirt is trudged off to surrounding huts for other prospectors to sift for its gold content. The back-breaking labor worsens daily as the miners dig themselves deeper into the earth, lengthening the distance they must climb to the mine's edge. In a few years Serra Pelada has produced enough gold to make an impact on Brazil's staggering foreign debt, and to relieve that country's 35 percent unemployment rate. But the *garimpeiros*, with their crude mining methods, are only able to skim off the richest surface deposits before moving on. Such primitive high-grading is now being discouraged by foreign mining interests which wish to optimize one of Brazil's prized resources.

> To those who hope for a return to some kind of a gold standard, [Brazil] matters very much. Gold still plays an important role in the world monetary system, providing nearly two-thirds of the reserves of the world's central banks. World gold production peaked in 1970 and has fluctuated since then below the peak. Of all the gold-producing countries, past and present, Brazil seems to have the best chance of making up a considerable part of this shortfall.[7]

The tragic irony of developing countries such as Brazil consists in the fact that they are victims of their own formidable contributions to the progress of world capitalism; their role as sources and/or reserves of raw materials shackles them to a state of perpetual industrial "backwardness," which generates unemployment and tremendous poverty within a larger world flooded by commodity goods such countries have contributed to but cannot afford to buy. Serra Pelada is undoubtedly an immense resource for the developed world's industrial and financial centers; but the actions recently planned to be taken for producing capital — gold — more efficiently would have dire consequences upon the livelihood of the mud-caked miners. These have, in turn, resisted plans to give Serra Pelada over to a state mining firm whose mechanized equipment had been expected to double gold production. Such is the *garimpeiros*' political clout, that Brazilian mining laws now require manual methods which guarantee the miners' ongoing employment. Today, the standoff between Brazil's *garimpeiros* and First World mining

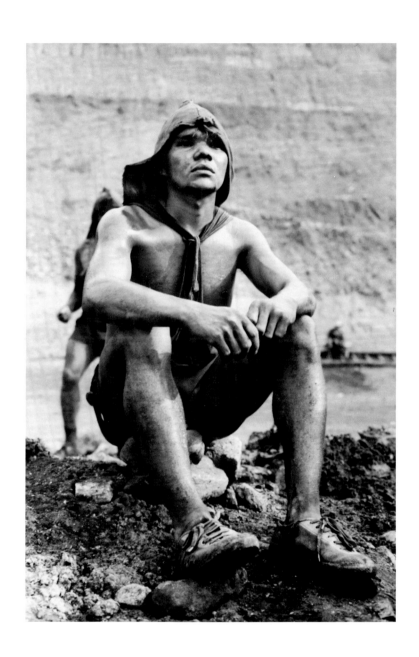

interests continues, and no political solution has yet been found. Serra Pelada stands as but one more case of the First World's demands for technical "advancement" and mechanization and its shouldering aside of the Third World's more basic and immediate need for employment.

Gold in the Morning does not focus on the economic and political strife at Serra Pelada, but on the grueling quotidian labor, transmuted and refined into five mid-size photographic transparencies elegantly illuminating a darkened room. The inner light and sculptural strength of these photographic constructions charge the images with a liveliness not otherwise possible in the immobile, flat rectangle typical of the photographic medium. Installed below eye level, one image surveys the mining operation from an omniscient viewpoint: it is a kind of picture space evocative of gothic art, where even outdoor vistas were created as contained and enclosed areas by high horizon lines and perspectival foreshortenings. Here, the physical immensity of the mine is defined by long, slanting water pipes and sloping paths, and by the ant-like scale of the laborers. Another image offers a closer look at a powerful grouping of bodies, repetitively — relentlessly — hunched over with the weight of their herculean loads, their diagonal thrust generating a dynamic space. A third light box jump cuts to an image of sheer physical strength, in which a single, apparently headless torso is carried uphill by muscular legs: here the beholder must look down into the picture, which results in the impression that he or she stands, literally and symbolically, directly above this powerful body. Here, too, the light box's location on the floor reinforces the sense of weight, oppression, and gravity. The foregoing images contrast markedly with a frieze-like assembly of cocky, confident miners, and with a close-up portrait of a solitary miner. By focusing on a few individual countenances, Jaar restores to the miners their separate identities, and reveals their utter self-confidence in the face of a sisyphusian quest. The high mineral content of the Serra Pelada earth and mud has coated their bodies with a fine, silvery, uniform film reminiscent of the patina of old master paintings. This quality of temporal remoteness is unwittingly corroborated by the miners' antiquated headdresses — actually burlap hoods worn for protection both from the sun and the strain of their sackloads. In fact, the scenes seem less a slice of life, than a fragment from some bygone, preindustrial epoch, embalmed in a brown melancholy light.

The five light boxes are each coupled with like-sized gilded metal boxes whose radiant surfaces are reminiscent of Byzantine grounds for portraits of saints and martyrs. Onto these spaces tacitly indicatory of a state of ideal perfection, Jaar's icons of brute labor reflect and dissolve. In fact, *Gold in the Morning* is invested with a considerable degree of religiosity, with its darkened shrine-like setting, its glowing light boxes depicting a kind of contemporary purgatory, and the light boxes'

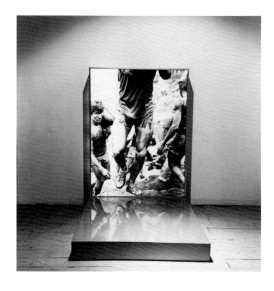

Gold in the Morning, 1986 (detail)

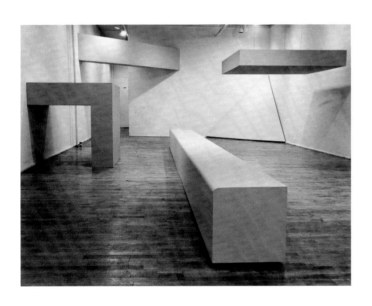

Robert Morris
installation view, "Robert Morris," 1964
The Green Gallery, New York
Courtesy Leo Castelli Gallery, New York

gilded appendages or "attributes." The combined, magnetic forces of gold and of religion form the installation's historical subtext; after all, it was the obsessive search for gold, hand in hand with the promulgation of the "word of God," which spurred the European "discovery" of the Americas almost 500 years ago. Even at that early date, Latin America — its mineral-rich depths, its people, and their capacity for work — was transmuted into capital accumulated for and nourishing distant centers of power. The rich and deeply rooted dream of El Dorado — the mythical kingdom that fueled the faith of the early European colonial mind — finds its contemporary counterpart in the often fruitless gold rush, indefatigably played out in Serra Pelada and hundreds of mines like it, day after day.

Formally, the light boxes, together with their gilded counterparts, form L-shaped structures which hug the architectural elements against which they are set, accentuating the installation's literal environment of corners, floor, walls, and ceiling. As intriguing as Jaar's actual boxes is their positioning: in arranging **Gold in the Morning**, Jaar consciously avoided placing any of its components at the level of the viewer's sight line, usually approximated at 5'5". The activating of the exhibition space by offbeat placements or the introduction of anomalous objects is, of course, in no way new: as early as 1915, the Russian painter Kasimir Malevich's nonobjective canvases were hung, by the artist's choice, high up and away from the viewer, thus dramatizing the traditional relationship between audience and art work. Frederick Kiesler's early-forties surrealist design of Peggy Guggenheim's Art of This Century gallery — with curving walls and wooden biomorphic furniture — attempted to plunge the gallery's contents into the space of the viewer; while Marcel Duchamp, that arch-anti-aesthete, contrived for his contribution to a 1942 New York exhibition a piece consisting of "a mile of string,"[8] that, in winding like a spider's web throughout the gallery space, radically altered — inhibited — the viewer's usual relation to the work viewed. More recently, Minimalism's "specific objects," influenced by phenomenological concerns, were structured and then placed within gallery spaces in such a way as to emphasize the perceptual and physical *inter*relationships between subject and object, viewer and art work. The location of Jaar's own light boxes within **Gold in the Morning**'s exhibition space embodies, however, unlike Minimalist pieces, a metaphorical import as well. The marginal placement of these boxes is the physical equivalent to the marginal site we reserve for those "others" located on the periphery of postindustrial production, economically, politically, and culturally. The individual lives of Third World people, in particular those whose existence consists of manual labor, are almost wholly ignored in the economic and deindustrialized centers of the West. Jaar underscores this exclusion and virtual invisibility within Western institutional frameworks (including

that of the museum), by deliberately situating his images of laborers, immigrants, children, etc., at the outer edges of his installations. Indeed, the underdeveloped world is mostly shuffled out of sight and out of mind, even as its natural and human resources are raided for the raw materials of our prosperity. This situation is recapitulated at the center of the installation, where a massive bed of nails supports an ornate gold leaf picture frame. Bereft of its function, the frame, an opulent replica of an eighteenth-century Venetian original, complete with a molding of foliate scrollwork, is a forceful symbol of the gratuitous excesses of Western capitalism. The bed of nails on which it rides refers to the martyrdom of the Christian saints, and by extension, to the first Crucifixion (a subject commonly "framed," in fact, by Italian Renaissance and Mannerist painting) — and thus to the inordinate power still exerted by Catholicism over the Latin American world. Yet, the massed nails also suggest the sheer, wanton numbers of people whose excruciating toil and "passion" literally sustain our way of life, fill *our* world with ease, self-complacence, and luxury goods. As the nails within the picture frame are made to turn gold, so in the cruel alchemy of today's global division of labor, the Third World's natural and human resources are transfigured into First World capital.

In the ways that **Gold in the Morning** exposes the chafing, brutal economic bond between the First and Third Worlds, it finds its artistic precedent in Hans Haacke's conceptual work. Both Haacke and Jaar have a detached yet committed attitude toward their subject matter: further, they share a working method which begins with thoroughly researched factual material, transposed into carefully crafted installation works that challenge the separation of art from global or socioeconomic events and claim for art a social purpose. Haacke's pieces, however, often target among other things particular international corporations and their specific abuses of the Third World workforce: for example, *Les Must de Rembrandt* (1986), which consists of a bunker vaunting a mock facade of a Cartier boutique and a photograph of South African black miners, clearly establishes the links between the Cartier Monde Corporation and GENCOR, a South African mining firm infamous for its inhuman treatment of black labor.[9] Jaar's installation, on the other hand, abstracts from and mediates events in the workers' lives, transforming Serra Pelada from a grueling mining operation into a metaphor for the larger human conditions of power, disenfranchisement, desire, and faith. Jaar's approach to Serra Pelada is also informed by his training in architecture and film. Much as an architect might follow a period of intense research with a concrete, statistical documentation of the project at hand, Jaar first comprehensively documented the Brazilian gold mine, completing over 1,200 separate photographs and ten hours of videotaping. Jaar's grounding in filmmaking kept this "location shoot" flexible up to the editing stage itself. Following his trip

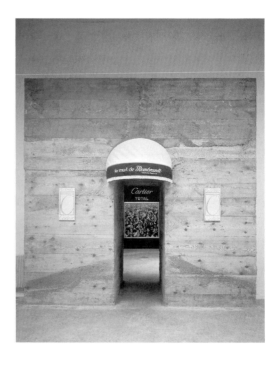

Hans Haacke
Les Must de Rembrandt, 1986
two-room installation
exterior facade of concrete bunker,
12' 2" x 12' 2" x 5' 11";
concrete walls, 9' 10" x 26' 3";
interior facade of boutique, black lacquered wood
with black-and-white photograph,
9' 10" x 9' 10" x 13"
Courtesy John Weber Gallery, New York

to Brazil, he spent close to a year carefully distilling this surfeit of visual imagery down to the five photographic light boxes which now compose *Gold in the Morning*. The light box is itself an intersection of film and architecture: a locale where the photographic image, enlivened with an interior light source which simulates the light of daytime, is set in a three-dimensional format which approximates an architectural space. Further, Jaar's subtle yet disjunctive installation of the light boxes points to a sophisticated understanding of the uses not only of architectural space but also of cinematic montage.

▲

Jaar has produced several other installations inspired by Serra Pelada, including *Welcome to the (Third) World* (1986), and *Rushes* (1986-87)(pp. 54-56), a work located in the Spring Street station of the New York City subway system. Pursuing his interest in marginal spaces as the metaphoric sites for the Other, Jaar chose the subway for its underground and therefore disavowed location. During the months of December 1986 and January 1987, Jaar leased the station's entire advertising space — a length of about two city blocks — on both northbound and southbound platforms. Using an advanced computerized process called electrostatic dot plotting, he produced eighty poster-size images derived from his photographs of the Brazilian mine. Framed like enormous paintings within the advertising panels, the images were nevertheless made to be four inches short of the available space, as if to state that the Other could not quite be "fitted" within — *refused*, in fact, to fit — these social, economic, ad-mass boundaries. What accounted in great part for *Rushes'* almost irresistible force was its virtually automatic appeal to the viewer, so thoroughly schooled in the reading or reception of advertising images. The terms endemic to commercial display — that of attracting attention, arousing interest, and stimulating desire — worked to draw the observer/pedestrian into the piece, even as Jaar contested this rhetoric of persuasion.

Both the scale of the poster images and the structure of their installation spoke directly to Jaar's understanding of the language of contemporary experimental film. More particularly, Jaar used cinematic techniques designed to fragment traditional narratives. Instead of a story unified by the coherence of a plot line, *Rushes* was regularly broken or segmented by abrupt shifts in tone, at once visual and thematic. Film stylistics such as rapid cutting, the interference of written language with the flow of images, the use of unmatched shots, the slight alteration of otherwise identical takes, all counteracted ordinary plot development while still suggesting a sense of drama, even of mystery.

In fact, *Rushes* initially read much like a storyboard, with five or six images constituting "sub-plots" within the larger whole. One advertising panel, for example, depicted a close-up of feet and ankles in motion, which panned into an adjacent image of torsos and full figures, thus conveying in telegraphic fashion the speed and energy of the miners at their task. Elsewhere, close-up shots of faces or panoramic views of men bowed to their work were juxtaposed with images of burlap sacks filled, not with gold, but with refuse, and stacked to overflowing beyond the image's edge; these shots were positioned close to the subway garbage cans, the burlap sacks' big-city counterparts. Still other images were repeated in clusters of three or four, as if to insist that they be seen and registered, not merely glossed over: each of the panels forming one of these clusters was of a slightly different, bled or exhausted hue. Jaar deliberately leeched his images of their full color so that the resulting pale, raw tints could not be confused with the high-pitched dyes commonly employed in advertisement graphics. Finally, interspersed with this pictorial montage were lettered and numbered signs — much like movie subtitles — announcing the then-current price of gold on the world's financial market.

The success of this installation was due in great part to its multiple levels of structural, compositional, and metaphorical open-endedness. Since the subway physically lets on to many entrances and exits, the piece was open to various sequences of "reading," depending on the point at which the pedestrian/viewer entered the installation. The arbitrariness of the installation's unfolding permitted it an indefinite number of versions, all concocted by the viewer, who, in circulating round the station generated his or her own meaning from the medley of disparate shots. *Rushes* was also perceived in a totally different fashion by the passengers using the local and express subway lines running past the platforms. From within the moving train, the images along each long platform elided into a fully cinematic 'short.' In *Rushes*, as in all of Jaar's works, it was the viewer's presence — his or her "collaboration"— which enabled the installation to come into full being. Equally important to Jaar were the symbolic implications of the installation's site, in the heart of Manhattan's commercial art district (Soho) as well as on the southbound subway line to Wall Street, a First World financial center. By converging images of the lives of Brazilian miners with the lives of both Manhattan commuters and art world retainers, Jaar collapsed the physical and, arrestingly, the mental distance between these otherwise disparate groups of people. Disquieting parallels could be inferred between, on the one hand, the *garimpeiros* who over and over descend into the earth in their search for gold and, on the other, the rush-hour urban workers who relentlessly follow a hellish underground route toward the same alluring dream, and the art makers and purveyors who for the most part prop up or reinscribe that dream,

however pernicious, however false. The desire for wealth and eventually power is the common motivating factor in these contemporary and simultaneous "gold rushes."

Jaar is no stranger to art in public spaces: in 1980 in his native Chile, he leased three billboards along the principal pedestrian and vehicular thoroughfares, one located in the capital of Santiago, another leading to the international airport, yet another next to a freeway interchange. For this work, Jaar isolated a single sentence from everyday speech and printed it in mammoth capital letters against a white background: "¿ES USTED FELIZ?" (Are you happy?). The same piece was also displayed, placard-size, on newspaper stands, directly under public clocks, and at other locations to which the pedestrian's eye would be casually drawn. Jaar's earliest intervention into the confused and contradictory field of signs that populate public areas simply, then, posed this unanswered — perhaps unanswerable — question: his work thus diverged sharply from the authoritative forms of address and modes of persuasion characteristic of public signage. Rather than telling the passerby what he or she should believe or buy, Jaar simply set in motion a cautious dialogue which probed the viewer's most personal convictions. This at once public and discreet installation attests not only to Jaar's understated methods and to his predilection for audience participation: it also bears active witness to the censorship which has prevailed in Chile since General Augusto Pinochet's military dictatorship seized power in 1973. No regime in Chilean history has been more authoritative, or indeed, more brutal in its repression of differing views or of discontent. Having grown up amidst tyrannical conditions, futile protests and profound mass unhappiness, Jaar has, not unnaturally, gravitated towards an art practice pivoting upon sociopolitical issues. Further, the pieces he has so far made evidence a powerful aversion to dogma. The oblique form of address, in Chile a necessity for the survival of any form of artistic and/or political expression, has matured in Jaar's work into an elegant form of barbed political understatement.

Jaar has continued to locate his work in the public arena: for example, he produced *A Logo for America* (1987) on the computerized Spectacolor lightboard in New York City's Times Square. By means of a forty-five-second succession of computerized images, Jaar highlighted the way in which the language of the First World, whether visual or verbal, may possess, process, and homogenize the heterogeneity of the Third World. In epigrammatic fashion Jaar's animated short used a few, well-chosen images of a map and the flag of the United States to remind us that the word "America" actually comprises the entire continent of North, Central and Latin America, and not the United States alone. Like his contemporaries Dennis Adams' Constructivist bus shelters, Jenny Holzer's electronic message boards and Krzysztof Wodiczko's photographic projections,

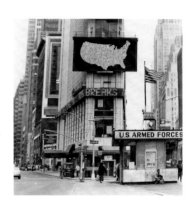

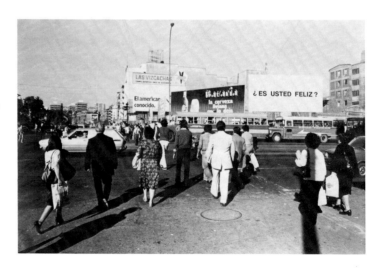

¿Es Usted Feliz?, 1980
billboard
Alameda Bernardo O'Higgins,
Santiago, Chile

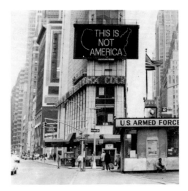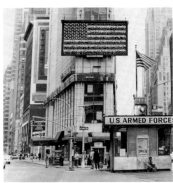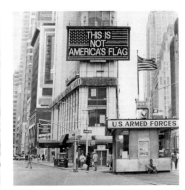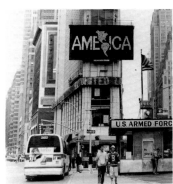

A Logo for America, 1987
computer animation, Spectacolor lightboard,
One Times Square, New York City
April 19 - May 2, 1987

Jaar's public art work differs from other public art in its mechanical or electronic production, its often temporary status, and its critical engagement.[10] Artists like Adams, Holzer, Wodiczko, and Jaar seek to undermine the power of the media that saturates public spaces, by opening up, through commandeering the media's own vehicles, alternative ways of thought. Certainly Jaar's works benefit from the innovations of his predecessors in Conceptual art, particularly those of Joseph Kosuth, who used the billboard in the mid-seventies, of Daniel Buren, who in 1970 installed his now famous striped panels in 140 Paris subway stations, and of Lawrence Weiner, who has recast any architectural surface into a ground for a radically reconstituted "poetry." Conceptual art, however, has tended to focus on dismantling general assumptions about the definition, status, and province of art itself. Jaar on the other hand, again along with Adams, Holzer, Wodiczko and others, has expanded upon these critical aesthetic concerns to embrace seemingly far more immediate social and political levels as well.

With the installation **Frame of Mind** (1987)(pp. 57-59), Jaar adjusted the light box's orientation in a particular way which has

since become crucial to his work. In installations like *Frame of Mind, Coyote!* (1988)(pp. 64-68), *Modernism is Dead, Long Live Modernism* (1988)(p. 72) and *The Turning Point* (1989), the light box is turned away from the viewer and placed approximately two feet from the wall it has now been made to face. This positioning initially accentuates each light box as a free-standing, sculptural form. Given that its back side — whether plain or perforated — is the first facet one sees, the box curiously conjures up the well-crafted industrial modules typical of Minimalist sculpture which similarly highlighted form and function. This particular arrangement has the advantage of shifting attention away from the photographic transparency inside the light box to the transparency's *frame* — that is, to the container which determines the photograph's shape, both physically and, ultimately, ideologically. The viewer is thus drawn from a consideration of the work's purely visual and/or material properties, to a Brechtian cognizance of the *means* by which its subject matter is represented. Across from and slightly higher than the top of each light box hangs a mirror, its frame baroque in *Frame of Mind*, neoclassical in *Coyote!*, and "high modern" in *The Turning Point*. On the viewer's approach, the mirror, hung so low that it at first seems bereft of its reflexive function, begins to reveal the photographic image across from it. Integral, again, to the realization of these art works are the movements — the bodily "commitment"— the viewer must make around the light box in order to perceive the image: it is only with some conscious effort and deliberate realigning that he or she can organize what surfaces in the mirror into a coherent and singular whole.

The mirror is "an instrument of self-knowledge,"[11] the empty, reflective object before which we typically pose questions about ourselves, and the strange talisman with which we assure ourselves of an imaginary, yet utterly convincing, identity. We have grown accustomed to believing that the mirror gives back an unaltered vision of who we "really" are. For that reason, it becomes all the more discomfiting to peer into Jaar's "looking glass" and see, not a full-frontal reflection of a stable, confident self, but a stranger, at once partial and unresolved. In *Frame of Mind* and *Coyote!*, a bisected head slowly emerges from the mirror's bottom center panel into an almost life-size image of a face that stares uncompromisingly at us: in the former work, the face is that of a Brazilian miner, in the latter, that of a Central American immigrant. The metaphorical loss of identity we are compelled to experience in all Jaar's mirror works is the beginning of an undoing of the dominant, subjective point of view. It is with this undoing that Jaar's work acquires its greatest resonance, addressing head-on the relationship that exists between ourselves and outcast or denied others. The problems inherent in representing the Other have been widely discussed in recent years, in the annals both of anthropology and art criticism. The issue for Jaar and for us, however, is that our Western culture, in the vast majority of relationships, has been the principal, overbearing partner, and has dictated the terms of exchange. Those terms have, almost exclusively, favored European and/or North American people: the privileged skin color being white, and the privileged sex, male. The forfeiting of identity or self which Jaar's mirrors effect suddenly permits a dialogue — even a confusion — between subject and object, seer and seen, self and other, in which neither party holds a preferred position. Our traditionally ego- and ethnocentric point of view thus suffers, in most all his installations, a remarkable shattering.

> In this unwonted spectacle made of reality and fiction, where redoubled images form and reform, neither I nor you come first. No primary core of irradiation can be caught hold of, no hierarchical first, second, or third exists except as mere illusion. All is empty when one is plural. [12]

Reflection takes place upon a symbolic or structural as well as a literal plane; and the physical features of Jaar's work correspond to — even as they attempt to subvert — the unequal power relations that persist between our Western selves and a disembodied stranger, not-self, or Other. Another light box in *Frame of Mind* is suspended from the ceiling, its image of Brazilian miners reflected and fragmented by a grid of nine framed mirrors spread on the floor. The spectator's viewpoint as he or she looks down upon the reflected image implies a superior, omniscient stance, yet this spectator's own image, as much as that of the Other, is also splintered and diffused by the mirrors and the grid of heavy frames. Both the observer and the observed are thus treated to a destabilization and an oscillation undermining their respective positions and authority, or lack thereof. Their mutual fate in a reflected diaspora of colors and lights points to an alternative relationship between viewer and Other: a "model of cultural confrontation" in which a dominant or, better still, no longer dominant culture can share the space with another culture "without obliterating it."[13]

> Yet how difficult it is to keep our mirrors clean. We all tend to cloud and soil them as soon as the older smudges are wiped off, for we love to use them as instruments to behold ourselves, maintaining thereby a narcissistic relation of me to me, still me and always me. Rare are the moments when we accept leaving our mirrors empty....[14]

As deployed by Jaar, the mirror does not allow itself to be used as a vehicle of narcissistic contemplation; it is, rather, a locale of phenomenological flux in which neither our own image nor anyone else's can be fixed, or fixated upon. Rather than basking in the certitude of our own image or taking possession of the Other, we are forced to peer into a common ground or no-man's land, and to initiate a dialogue that has no sure terms, goal, or end.

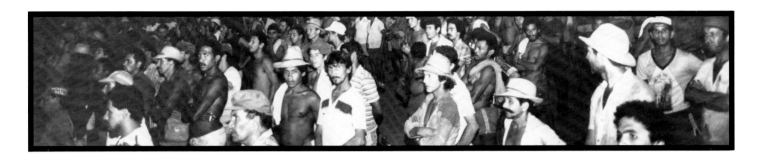

Untitled, 1988
light box with color transparency, edition of three
18" x 8' x 7"
Collection Milton Fine

Due to the mirrors' rather intimate size, they cannot encompass in their reflection the entirety of the much larger photographic transparencies: thus the Other remains circumscribed, cropped, amputated, and delimited within the mirrors' frames and thus in our eyes. Even as we maneuver around each light box in an effort to complete its picture, the image is haunted by some as-yet inchoate or unresolved aspect outside and beyond the fact of representation. The limited viewpoint and inherent physical distortions (mirror reversals, fragmentations) to which we subject the Other in the mirror reflect or embody the limits of Western representational discourse in general. No amount of documentary photography or statistical information can correctly translate for us the people or cultures of the Third World: instead, they almost invariably remain "a mirrored reflection of our own psychic demons,"[15] deformed by preexisting conceptions we have imposed upon them, and "framed" by our own cultural constructions (i.e., our language, our art, our politics, our religion, etc.). In fact, *mis*-representation thoroughly inscribes the relations between the First and Third Worlds.[16] Just as the mirror image has no substance — in reality does not even exist, is a phantom — so *all* our representations of the Third World give back to us only "false" and fragmentary specters.

Jaar's works are driven by the desire to expose "the misrepresentation that 'lies' beneath the surface of photographic representation,"[17] especially beneath so-called "documentary" photography. Because of its apparently "factual" character and its commonplace use, we tend to absorb the photograph instantaneously, almost naturally, yet it is now well known that a photograph, far from being a window on the world, is a construct, shaped equally by the contexts that have produced it and that will eventually "revisualize" it.[18] In calling attention to his own formal devices, Jaar alerts the viewer to the arbitrariness — even artificiality — of the "reality" offered by the photograph. By obstructing direct access to his images, he precludes the photograph's being thoughtlessly and inconsiderately received. Further, by forcing us to engage with the light box and its mirror reflection, Jaar manipulates our actions to mimic those of the camera itself: i.e., to reproduce the way in which *it* first frames and then records reality onto a photographic emulsion via a mirror. Rather than accepting the photographic images as unmediated transcriptions of the real world, Jaar routes our attention to the nature of the photographic process itself and, consequently, to its limitations.

■

One of the most insidious ways in which our dominant Western culture has misrepresented the Other is through "concerned photography," which since the 1880s has peered at, pictured, and manipulated images of poverty and suffering. Edward S. Curtis' plaintive images of Native American Indians, Lewis Hines' turn-of-the-century photographs of child-labor abuse cases, Dorothea Lange's and Walker Evans' Depression-era photographs of destitute farmers, these are but a few in a long succession of perhaps well-intentioned photodocuments which

22 ultimately lend their visual testimony to special ideological interests and political ends.[19] Today, the photos in **National Geographic** magazine and CARE ad campaigns are the common offspring of this particular strain of photography. Far from being innocent reflectors of social conditions, such images are firmly entrenched in a rhetoric of universal brotherhood which, in even the best of circumstances, aspires to "improving" the lives of those pictured by focusing on their "dignity" and "humanity," to the exclusion of their individuality, complexity, difference.[20] These tokens of charity are never in the end positive; they solidify, whether explicitly or implicitly, our perception of their subjects as belonging irremediably to a pathetic, docile, and inferior class. In a sense, such photographs *cultivate* a look of misery, and thus a distancing and exoticism that purveys recorded wrongs, without seeking to correct them.

Those slow-moving files of refugees in stony landscapes, those motionless babies with flies clustered round the eyes — images like these belong to the realm of nightmare. They simultaneously arouse our compassion and debase our conception of the victim, who is seen as passive, dependent — the skeletal receptacle of what our charity can provide. I do not decry charity. If a man is drowning we must rescue him. But charity has its dangers. Chief among them is condescension. We have been kind, we congratulate ourselves, to the 'starving millions.' But who are they, these emblematic multitudes? Is it not possible that the abstractions in which we deal end, despite all our kindnesses, in further diminishing those whom we sincerely wish to help?... In the spirit of charity we go forth and denude them.[21]

Jaar's *1 + 1 + 1* (1987)(pp. 60-61) addresses the exploitative — necessarily aestheticizing — and potentially explosive depiction of the poor in the arenas of photography and art.

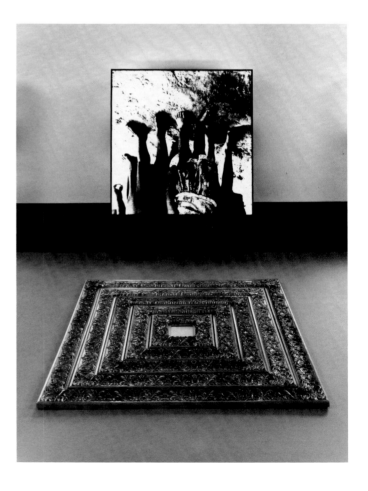

1 + 1 + 1, 1987 (detail)

Three light boxes are hung low to the ground, each depicting a different, inverted image of children clustered together — images Jaar culled from the archives of a photographic agency, and purchased. Understated clues to the children's deprivation — bare feet, unkempt clothes, and distended bellies — come to our awareness almost as afterthoughts, since the inversion delays our recognition of the scene through abstracting the composition. The focus, endemic to "concerned photography," on the pained faces has here been ruthlessly voided: the artist's camera and subsequently the viewer sever the children at the waist, leaving but the bottom halves of their bodies. Jaar thus underscores photography's violation of its subjects by brutal cropping which literally and metaphorically excludes the children from speaking within a system of authoritarian representation in which they are spoken for. Jaar further manipulates the photographs by re-touching and tinting them a sepia color. This color is more than a visual conceit, for its etiolating and distancing effect is a comment on "the impoverishment of representational strate-gies"[22] which cannot even begin to translate poverty and pow-erlessness correctly. Jaar seems to suggest that an *intentional* "impoverishment" of the representation is a perhaps more accurate way of presenting a reality that is an unknown already photographically estranged from us.[23] Further, the color per-forms the inevitable loss of meaning and exhaustion by which these images are consumed in this culture.

On the floor perpendicular to the boxes lie three sets of gilded frames which serve to disclose their own — i.e., art's — function as being typically one of artificializing and circumscrib-ing. Each frame configuration alters or mediates reality in one of the different ways art itself may refashion the world. "Read-ing" *1 + 1 + 1* from left to right, we are given first a single empty frame completely divorced from the image above it: emblemati-cally, art and life are parallel but autonomous realms between which there is no hope of connection. The second frame has undergone a mutation and multiplication which seem meant to embody the maxim, "art for art's sake": still incapable of catching the photographic image, this nexus of frames implies a deliberate exclusion of the outside world for the sake of solipsis-tic aestheticization. The third frame contains a mirror which strives to correct "reality" in the photograph by showing it in right-side-up reflection: here, however, the vision of poverty remains a mendacious illusion. For if we borrow, for a moment, the language of the "window on the world" metaphor, we can say that, in this installation, the viewer's attention is no longer concentrated solely on what lies beyond the "pane of glass" but also upon the distortions — the perversions — introduced into our vision by that "glass." The gilded frames perforce turn everything within their borders into a painting; and their subject matter, as a consequence, always veers uncomfortably towards the "picturesque" — toward a toothless quaintness. *1 + 1 + 1* is

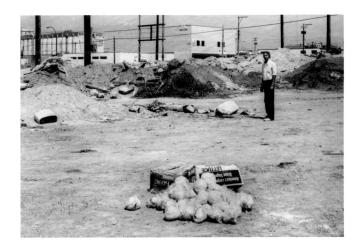

Jeff Wall
Bad Goods, 1984
light box with color transparency
7' 6 ¼ "x 11' 7 ½"
Collection Vancouver Art Gallery, Canada

a pessimistic as well as critical statement, for it grants equal footing to the three, all rather inadequate, alternatives by which our frames of reference capture the world. By inserting into fancy frames usually reserved for high art subjects heretofore excluded from them, Jaar's tactics are similar to those of Jeff Wall, whose photographic light boxes place the excluded and underprivileged in compositions mimicking the classic masterpieces of, for example, Nicolas Poussin or Claude Lorrain.

The production and use of images of underprivileged people in installations which they will neither see nor substantially benefit from begs the question of exploitation in the very arena where it is protested. Jaar's intelligent debunking of unequal power relations disturbingly ignores or else minimizes the fact that his works function within a system of institutions — museums, galleries, trade journals — which are supported in part by the very same power structures that marginalize the Other. It is perhaps inevitable that Jaar's work should make us wonder whether or not he is guilty of sustaining relations that culturally annex the people deemed Other, granting them little more than an uneasy after-life as high art. This is a common and perturbing question which surrounds the work of any artist supposedly engaging issues of otherness and difference. It is a question that is peculiarly sharp where photography is the critical tool of choice. For to photograph something or even to deploy photographs is to implicitly encourage and protract the conditions photographed. Even when a photograph's subject is acute suffering — the impoverishment, the exclusion, the "otherness" — the taking of a picture is to have an interest in the things pictured remaining as they are.[24] And in taking photographs, the artist/photographer puts himself or herself "into a certain relation to the world that feels like knowledge — and, therefore, like power,"[25] certainly like privilege. Indeed, the photographic process itself is intimately bound up with the acts of domination, surveillance and control, and ultimately, self-congratulation. The photographic record often proves to be only the incidental result of the camera-holder — the photographer — posing him- or herself "as an author, situated *above* the work and existing *before* it, rarely simultaneously *with* it."[26] A rudimentary listing of terms describing the photographic procedure bears witness to its fundamental authority and arrogance — to "take," to "shoot," to "capture," an "arresting" image — is linguistic proof that the subject in the viewfinder is transformed into a target, a prey, to be symbolically possessed, even killed. The Other is reconstituted within the very arena of photographic representation as a depleted, mute, passive victim — as a lifeless fiction or a rag doll. The camera's appropriating eye "exposes" the Other to a degree of violence against which he or she finds himself or herself helpless. However honorable Jaar's intentions may be, the power relations implicit in the making and using of photographs inevitably support a representational system that excludes the

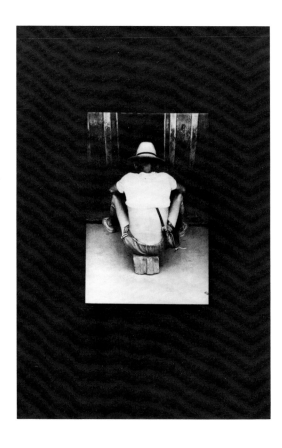

Waiting, 1988
light box with color transparency
6' x 48" x 7"
Collection Linda Smith

others, denying them access to their own means of direct expression.

It would, though, be a perhaps far more dangerous policy to spurn this kind of art simply because of the questions it raises. Were Jaar to avoid using images of marginalized people altogether, these people would remain not only the silenced, but also "the *invisible* victims of Western ethnocentrism."[27] Nor does Jaar merely represent such people: rather, he points up and challenges the relation between dominant observer (us) and subservient observed (them), by frustrating the observer's long-nourished desire to visually "possess" the people, lands, things. He does so, as we have already seen, through physical obstructions, through techniques of cropping and inversion, and through the elimination of explanatory texts or captions. These oblique devices hamper our authoritarian impulse, allowing the Other to assert itself to whatever extent possible within the art work's context.

▲

Similar issues inform ***Coyote!*** (pp. 64-69), a work in which our encounter with the underdeveloped world is one unnervingly close to home, and for that reason all the more troubling. An exotic or remote subject like Amazonian gold or abject poverty might still permit the sense of a comfortable distance between ourselves and the Third World. But the illegal immigrant who crosses the United States/Mexico border into the U.S. is intricately involved with our national life, economically, culturally, and politically. For years (but especially since Mexico's economic crisis began in 1982), a countless number of people, escaping economic disaster in Mexico or civil war in Central America, have crossed the porous 1,952-mile border in what has been described as "one of the great human migrations in history."[28] The root causes of this immigration are of international origin and concern. In Mexico, for example, the foreign debt's prolonged impact, together with an alarming population increase, has stunted domestic economic growth and resulted in mass unemployment. Concurrently, the cost of labor in developed nations has enormously increased the demand — especially, for instance, in the U.S. agricultural and service industries — for the unskilled work force Mexico can provide. In effect, Mexico and the United States participate as unequal partners in a single tightknit economic system.

Illegals in Silicon Valley make printed-circuit boards for IBM personal computers and assemble microchips for use in guided missiles. In Southern California, they make artificial-heart

valves.... Elsewhere in the Southwest, they package contact-lens solution and arthritis pills, assemble baby strollers, pluck Thanksgiving turkeys, stitch Levi's sportswear and help make air conditioners installed by General Motors and Chrysler dealers. Illegals also improve the quality of life for millions of Southwesterners by keeping their offices spotless, by making home improvements affordable, and by watching the kids so mom can hold a job.... Undocumented Hispanic workers, in fact, are the backbone of the Southwest economy.... This economy was built on the assumption and reality of a heavy influx of illegal labor.[29]

Willing to accept meager wages and hard working conditions, without benefits, most of the undocumented immigrants — the majority of them Mexican — enter the United States either through the Rio Grande Valley in South Texas or by way of Southern California. In approaching this immensely complex subject, Jaar chose to focus only on the passage across the Rio Grande, which so many of these immigrants have made. The hazardous crossings are largely effected on the backs of *coyotes*, professional smugglers who charge several hundred dollars to transport their payloads across the rushing waters. In selecting images from the mass media for use in his installation, Jaar deliberately focused on marginal moments in the lives of those concerned in the events, rather than parading the more dramatic aspects of the crossing, and its risks, as the mass media would customarily do. We are thus made privy to a group of workers meeting to discuss better living conditions for themselves; to a lonely immigrant waiting or perhaps detained; to another, older man shown from behind resting on a block of wood.

The centerpiece of ***Coyote!*** consists of an almost life-size image of two smugglers navigating the waist-high crosscurrents, each carrying an illegal immigrant piggyback style. The work's large scale might encourage an illusion of accessibility, yet its image hangs upside down to emphasize our distance from the scene. The only way this image can be seen right-side-up is by looking *down* at its reflection in a pool of water. Evoking the waters of the Rio Grande, the pool's fluid, always shifting — because always troubled — content infuses the imaged figures with a movement and a liveliness much like what they must originally have possessed, the "watery screen" thus subverting the static quality of the photographic picture it carries. This flux also results in a type of disturbance instrumental within Jaar's work in general. The delay in identification that Jaar effects is crucial to a "resistance" we are forced to experience, even if only momentarily, to our limited and traditional reliance upon an immediate categorization, or stereotyping, that, here, might cause the *coyotes* and the illegal immigrants to be construed as degenerate types.[30] Instead, *coyotes* and immigrants are seen to be complex and finally unfathomable, exhibiting a countless number of shifting nuances. Jaar's strategies not only refuse to "correctly" represent otherness; they also move to disarm a

potentially ethnocentric response. It is interesting to note, too, that *Coyote!* pays homage, in its title, to Joseph Beuys, whose performance, *Coyote: I Like America and America Likes Me* (1974), sought to reconcile the white European people — represented by Beuys — to the Native American race — represented by a live coyote. By sharing living quarters with the coyote unharmed for a week, Beuys subverted its stereotype of an aggressive, blood-hungry trickster, and restored to the creature its earlier status in American Indian folklore as a respected and venerated deity.[31] As Beuys' "social sculpture" sought to heal social wrongs, so Jaar's installation expands the concept of art to include larger social problems in the hopes of transforming them through awareness and discussion.

In looking into the pool of water, Jaar forces us to enter into a narcissistic posture that echoes or reflects the general yearning for possessions driving the cycle of supply and demand to which the *coyote* and the undocumented worker have been harnessed. In essence, *Coyote!* catches and briefly holds the viewer in a permanent meditation upon the nature of economics, labor exploitation, and consumer goods. That its subject is such a meditation is signaled, in part, by its mechanism of the light box, a device symbolically charged due to its widespread use in the commodity world of advertising. Into this arena of the advertisement, normally reserved for the crass embodiments of our myths, dreams and desires, Jaar inserts the oppressed and ordinarily *suppressed* — i.e., invisible — labor force responsible for transforming raw materials into the luxury goods we obliviously enjoy. In effect, then, Jaar at once deftly and radically short-circuits the cycle by which raw stuff is converted into objects promoted and sold by advertising. At the same time, his work belies the advertising media itself by substituting for its images of luxury products and pseudo-sophisticated people, images of such products' and people's brutal economic underbelly. Such a strategic deployment of images and advertising techniques recalls the work of Victor Burgin, who in the mid-seventies recycled the rhetoric of advertising into telling phototexts through which "the actual material condition"[32] underlying the mass media's message was blisteringly exposed. Informed by theories of both psychoanalysis and semiotics, Burgin's critique of advertising generated "new pictures of the world"[33] that exposed the economic abuses and the purely commercial motivations behind the advertising media.

In fact, Jaar's unmasking of the mechanisms of advertising, as well as his re-vision of the Other, could not have been possible without the precedent of feminist theory and art practice (to which Burgin among others has greatly contributed). Since the early seventies, feminist practice has developed a body of thought and work informing and crucially influencing nearly every aspect of cultural activity. Feminist critiques have addressed and attempted to dismantle the dominant forms of

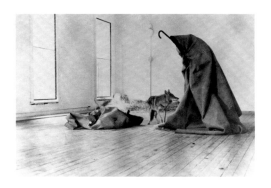

Joseph Beuys
Coyote: I Like America and America Likes Me,
1974
action, Rene Block Gallery, New York
Courtesy Ronald Feldman Fine Arts, New York

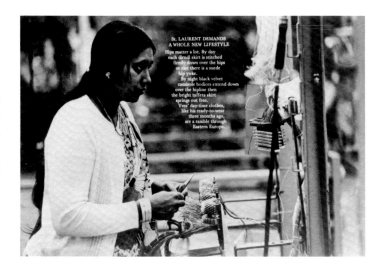

Victor Burgin
St. Laurent Demands a whole New Lifestyle,
1976
photograph mounted on aluminum,
edition of three
40" x 60"
Courtesy John Weber Gallery, New York

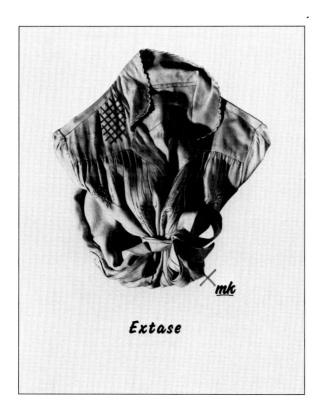

Extase

Mary Kelly
Extase, from *Interim. Part I, Corpus*, 1984-85
(detail)
laminated photo positive, screenprint on
plexiglass
48" x 36"
Courtesy Postmasters Gallery, New York

Western representation through which ideology shapes gender differences. Such critiques, generally speaking, expose the ways in which the governing discourse renders certain parts of the population invisible — not just women, but the poor, the homeless, the ethnic (i.e., the Chicano, the African American), for example. These "others" are absent except as images, specters constructed by the dominant cultural apparatus — the mass media. The resistance to the traditional Western representational vision — "as it converges on the patriarchal white male"[34] — begins the process of recognizing once marginal and excluded not only entities, but discourses. A number of artists have articulated this theoretical position. Mary Kelly's ***Interim*** (1984-89) relays the experiences of middle-aged women, a mostly silent (silenced) and ignored segment of our society: a segment so invisible, in fact, that Kelly does not actually picture these women in her work, but employs pieces of clothing parts — i.e., pieces of concealment and circumscription — as stand-ins for their bodies instead. Silvia Kolbowski's ***Model Pleasure*** (1984) subjects images from fashion magazines to a transmutation which discloses the ways in which women are made into objects of fantasy ("the idealized and subjected Other"[35]) and are thereby excluded from true representation. The way in which Jaar continually upsets the stability of our position as secure viewers is akin to Barbara Kruger's earlier strategic use of linguistic terms — "I," "you," "they," "my," "we," "your" — with no fixed masculine or feminine content, and always somehow implicating us, no matter who we are, as onlookers. Also, the incommensurate images of the Other we glimpse in Jaar's mirrors inhabit the same terrain as Cindy Sherman's "mirror-masks that reflect back at the viewer his own desire" — that is, "the masculine desire to fix the woman in a stable and stabilizing identity"[36] (Sherman's later photographs often displace the body altogether). Finally, the space into which Jaar's work ushers us — a space that we share with the Other, that inhibits our taking possession of the Other, is also the feminist space which nourishes "difference without opposition,"[37] and a deliberate "refusal of mastery" which is "more than technical."[38]

With ***Coyote!***, Jaar introduced a rectangular light box module of long, thin proportions that has since developed into a separate and ongoing body of work, ***Out of Balance*** (pp. 70-71). This series of light boxes is installed horizontally well above or well below eye level, or, occasionally, leaned vertically in a casual manner against the wall. Such unconventional placements break free from in order to disavow the "natural" sight line; they actively prevent, on the viewer's part, a certain visual complacency and prompt not merely a reconsideration but also a reorganization of the architectural space within which the works are set. At the same time Jaar problematizes the notion of point of view itself, the idea that what the art object offers is a coherent attitude or a single position by which the world may

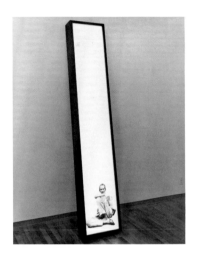

Cries and Whispers, 1988 (detail)

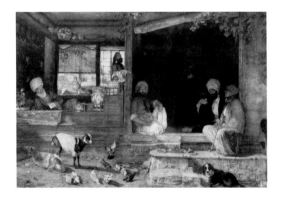

John Frederick Lewis
The Kibab Shop, Asia Minor, 1858
oil on panel
20 ½" x 30 ½"

be comprehended. Jaar carefully generates multicentered and contradictory viewpoints, inviting us to work out the possible relationships, which remain always provisional, between these various outlooks or positions. Jaar's is a *productive* mode of re-examination, and he carries it into the very composition, invariably asymmetrical, of the image suspended within the light box: either one or two figures are always set, disequilibratingly, against a stark white background at the far margin of each work. The figures — ranging from *garimpeiros* to a Central American immigrant to a Brazilian peasant — are subjected, then, to a compositional decentering that points up their general displacement within the larger sphere of global cultural and economic conditions. The viewer's involvement is further enhanced by the figures' almost sculptural presence, by their magnified detailed features, and especially by the gaze of their eyes which pin and follow the spectator — suddenly become the work's object rather than controlling subject — with no respite. The cold white void these figures occupy strikes us ambiguously, for it lies fluctuatingly somewhere between a compression or a kind of "White" oppression, *and* a release from any visual representation that might cast them as exotic, remote, and inert — a pure receptacle or "tabula rasa" for the projection of a correct envisioning. The light box module adapted for *Out of Balance* has been used by Jaar elsewhere, in word pieces such as *A Star is Born* (1988)(p. 73) and *Gesamstkunstwerk* (1988), and in the two-part *Cries and Whispers* (1988), named after the Ingmar Bergman film and echoing, too, Bergman's famous "two-shot," where a face, seen full-frontal, is shown in close proximity and perpendicular to another face seen in profile.[39] In the latter work, Jaar's subject, an older Brazilian peasant, is photographically decontextualized, dispossessed of the larger world he inhabits, but by the same token freed from the exotic accoutrements which accompany the worst kind of retrograde, yet persistent, images of the Other.

Jaar has focused by no means exclusively on the representation of the oppressed: works such as *Reflections* (1989), *No More* (1989), *Fading* (1989), and *Modernism is Dead, Long Live Modernism* (p. 72) examine the image of the oppressor, specifically that of the military. Rather than detailing a specific abuse committed by a particular army, Jaar shows the armed forces at play, in symbolic maneuvers whose sole purpose is the bald and theatrical articulation of military might. Divorced from action, the military's self-conscious aestheticization, its "show" of strength, comes into cold and perfect focus. Jaar merely high-

lights the drama, elegance, and seductiveness inherent in the display of power with his own work's regimented format, hard surfaces, and impeccable presentation. Yet, in **Modernism is Dead, Long Live Modernism**, he also defuses the official rhetoric of authority by fragmenting and distorting its otherwise indisputable message within three diversely shaped mirrors, one a square, one a triangle, one a circle. These three shapes belong to the vocabulary of high Modernism, to the project of Modernist movements like the Bauhaus, which sought to integrate art, architecture, and design in an effort to transform society into a universal and universally coherent utopia. The square, triangle, and circle were the ideal and supposedly commonheld visual shapes upon which a pure formalist expression — an expression capable of transcending the discord of modern life — could be based. Jaar's re-presentation of military exercises within these emblems of high Modernist art underscores the military *as* high art: witness, more specifically, the formalist purity in the rigid rhythm of weapons, forearms, and caps; the Modernist purging of the individual gesture in the anonymous faces hidden in shadow; and the lifeless universality in the unspecified character of the soldiers (they are actually Chilean). History has shown that idealist artistic endeavours have almost always carried within them the seeds of an absolutist vision capable of being adapted to authoritarian ends. Though we have seen the demise of Modernism within the arena of "Postmodern" artistic discourse, it seems that Modernist canons still continue to enhance the persuasive spectacle of power.

Modernism is shattered, its authoritative stance virulently protested, by the cracked mirrors of **The Turning Point** and the tumultuous boxes of **The Fire Next Time** (1989)(pp. 74-77). Both works depict events dating from the stormy decade of the sixties, respectively student uprisings in London and Buenos Aires, and civil rights marches in the United States. These events formed part of a larger crisis, one of worldwide proportions, which split open in the mid-sixties, a crisis characterized by a fundamental break with the hegemonic ideals and institutional frameworks of the West. Deeply upsetting systems of public instruction and communication — schools, TV, and the press — the protests called for a critical examination of all aspects of cultural production, for a rigorous and unflinching exposé of the inherent contradictions and deep-rooted racial prejudices permeating all parts of daily life. Today, the sixties are being recovered and addressed on a number of cultural levels, including popular television, high fashion, and contemporary art practice. The latter has inherited from the sixties a penchant for actively intervening in the existing modes of cultural production, for, in other words, using art "as an instrument of social and cultural transformation."[40] **The Fire Next Time** forms a part of this reconsideration.

Fading, 1989 (detail)
light boxes with black-and-white transparencies
overall dimension 48" x 18' x 7"
light boxes, 48" x 6' x 7" (3)
Courtesy the artist and Magasin 3 Stockholm
Kunsthalle, Sweden

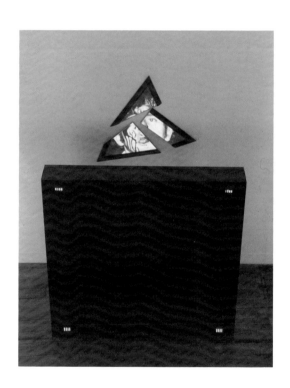

The Turning Point, 1989 (detail)
light boxes with black-and-white transparencies,
mirrors
overall dimension 50" x 13' 4" x 24"
light boxes, 40" x 40" x 6" (3);
mirrors, overall dimension 18" x 18" x 2" (3)
Collection The Progressive Corporation,
Cleveland, Ohio

The Fire Next Time assails the viewer with a chaotic grouping of long light boxes, the anarchic disorder of which is the sculptural equivalent to the violence and tension seen in the work's incorporated photographs. A collision of three-dimensional elements, this piece itself constitutes an aggressive architectural space; it is as if, before it, we also stood in the aftermath of a profound structural collapse — the collapse, perhaps, of a highly ordered Modernist "superstructure." Also, the color and coffin-like proportions of the work's modules lend a distinctly grim tone to the piece. Lining the light boxes on both their short and long sides are black-and-white photographs dating from the sixties of civil rights demonstrations in the United States. In their riotous groupings (as well as subject matter), these images betray Jaar's reliance not only upon the crazy reiterative structure of Warhol's *Race Riot* series (1964), but also upon a radically unprecedented cinematic style developed in tandem with — actually in response to — the political upheavals of the 1960s. Specifically, Jaar is indebted to Jean-Luc Godard's film techniques, which were capable of recapitulating far more accurately than conventional film the "grammar" of the convulsive events marking the era. Like Godard's cinema, the political imagery in *The Fire Next Time* is a collage of broken narratives told from various points of view by way of edit jumps, rapid cutting, and montage. Flash photography and "action shots" increase the sense of urgency and the feeling of being "on the scene." In the tradition of Godard, Jaar constructs, through the juxtaposition of dissimilar images, a sensory and, ultimately, a conceptual conflict intended to irrevocably disorient the viewer.

The cinematic structure of *The Fire Next Time* prompts the viewer to share in the work of (re)arranging its disparate, brokenly successive images into an intelligible order, to, in a sense, co-produce the piece. Given that the piece cannot be seen in its entirety from a single point of view, it demands a physical interaction translating, at last, into a powerful emotional involvement. In time, connections between images are made; severed photographs find their missing parts elsewhere in the installation; and the resulting links serve to complicate and reinforce the viewer's emotional engagement. This active reconstruction of the fragmented images leads, quite organically, to a critical recomposition of vision itself. A necessarily physical engagement evolving into an enlightened ethical engagement. *The Fire Next Time* is a provocation, a call to collaborate on many levels (physically, intellectually, emotionally, critically — morally). Its ruptures create a kind of suspended or open space; they permit the viewer to move beyond the images toward a critique and reexamination of these images' possible ways of being structured, of their possible *meanings*.

The Fire Next Time also has been made to assume the look of Minimalist sculpture, an art form which, of course, enjoyed great prominence and critical success in the sixties.

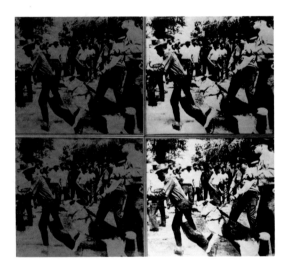

Andy Warhol
Little Race Riot, 1964
silkscreen ink on synthetic polymer paint on canvas
four panels, 30" x 33" each
Courtesy Gallery Bruno Bischofberger, Zurich, Switzerland

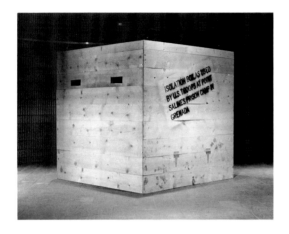

Hans Haacke
U.S. Isolation Box, Grenada, 1983, 1983
wood, hinges, padlock, spray-painted stencil
lettering
8' x 8' x 8'
Collection Hans Haacke

Jaar's light box module possesses a number of properties in common with the Minimalist "cube": it evidences a clean, impersonal geometry and is the product of commercially available materials as well as fabricating processes. Yet Jaar's work and that of the Minimalist sculptors break sharply over the issue of "content." Where Minimalism largely voided all figurative reference in the art work for a formally pure self-contained object, Jaar's boxes — elongated to clearly funerary proportions — are inlaid with specific political imagery. It may be suggestive to mention here again the work of Hans Haacke, whose earliest "content-fraught" pieces were contemporaneous with and reverberated against the mid-sixties works of Minimalist practicioners. Haacke's work, like Jaar's after him, divorced itself from Minimalist (or, rather, Modernist) formalism by incorporating, at first, a physiological and biological, and, later, a political context: for example, his fairly recent and controversial *U.S. Isolation Box, Grenada, 1983* (1983) is a straightforward reconstruction of the type of isolation chamber used by U. S. troops during the Grenada invasion. According to Haacke, this piece recycles Minimalism (i.e., the "cube" or "box") for contemporary use by critiquing and repairing that style's "determined aloofness."[41] Similarly, Jaar interjects the facts of a tumultuous decade into a form of expression which remained neutral and mute before these events. Of course, Minimalism was not without its own political agenda as it challenged then-dominant assumptions about art, but its efforts were felt almost exclusively, if not decisively, within the confines of artistic practice alone.[42]

The Fire Next Time may refer to the sixties on multiple levels, but its subtext is seeringly now or contemporary. First installed in The Brooklyn Museum, New York, its photo-images were intended to resonate powerfully for viewers whose city has become home to an increasing spate of racially motivated and interethnic violence, such as the murder of a black teenager in the Brooklyn neighborhood of Bensonhurst in August 1989. Fresh outbreaks of bias crime have occurred well outside New York too, have, in fact, become simply too numerous to be considered a series of isolated or maverick incidents. Sadly, Jaar's installation reminds us that the hard-won victories of the civil rights era may have been only pyrrhic; and the last three decades' successful legislation for civil rights — for full legal, social, and economic equality — may ironically have lulled us into ignoring the virulent racial schisms that still exist, schisms which find expression not only in outspoken violence, but in insidious forms of neglect and prejudice. By reviving the passionate, furious images of the civil rights movement, Jaar calls attention to the ongoing social torments, to the festering injustices, which permeate contemporary interracial relations. Further, in adopting a 1962 quote by James Baldwin for the title of his own work, Jaar emulates the stance of this essayist and writer — the darkly prophetic stance which warns contemporary American society of a retributive justice should its citizens not become, each and every one of them, instrumental in ending racial conflict. For "if we do not dare everything, the fulfillment of that prophecy, re-created from the Bible in song by a slave, is upon us: God gave Noah the rainbow sign, no more water, the fire next time!"[43]

Racism has as its essential premise the belief in the inferiority of those "others" who are different from "us." From this blind axiom spring the actions, policies and justifications which seek to exploit, even obliterate or destroy others. Since colonial times,

racism has been the instrument by which the First World consolidated itself as a sovereign subject and defined the non-European native as an exploitable resource.[44] By refusing the Other the same rights, the same access to identity, that one grants oneself, that Other is relegated to a position of inferiority, inequality and passivity, opening the way to a wholesale disregard for the Other's self and country. Certainly "tactics have changed since the colonial times and indigenous cultures are no longer (overtly) destroyed."[45] Rather than blatant imperialistic warfare, *neo*colonialism invades with the more subtle weapons of international corporate capitalism. In the last decade, and even more so within the past three years, toxic waste dumping has been the latest scourge normalized, if not overtly then certainly unconsciously, by racism, which allows the violation of the Third World and the appalling "redefinition" of its lands as so many dumping grounds for the excreta of "developed" nations. This violation constitutes a kind of contemporary update on the malpractices of the slave trade: a substitution of reeking flotillas of noxious waste for ships stocked with cargoes of human beings. The direction and terms of exchange may have changed, but they are still all one-way and quintessentially racist.

The exporting of toxic wastes to underdeveloped countries by industrialized nations stems from stringent disposal regulations in both Europe and the United States, designed to protect the health and environment of these regions' own citizens.[46] Faced with gross amounts of refuse, increasingly restrictive and costly environmental laws, and public unwillingness that toxic materials be located near them, industrialized nations have found it much easier to export their toxic waste to South and Central America and Africa, capitalizing on these countries' vast areas of undeveloped land, on their lax (if any) regulations over toxic waste disposal, and on their economic weakness. The cash-strapped underdeveloped nations are even less equipped than the industrialized countries to handle waste materials, lacking the necessary combination of technical capability, management facilities, monitoring infrastructure and environmental legislation to effectively control and process the received garbage; chemical compounds that could be disposed of rather innocuously in Europe or the U.S. present an immense health and ecological hazard in the developing world. *La Géographie ça sert, d'abord, à faire la Guerre (Geography = War)* (1989)(pp. 82-85) has its origins in Jaar's intensive research into, travel to, and photo-documentation of a clandestine toxic waste dumping site in West Africa. In February 1989, Jaar visited the small port town of Koko, located on the bank of the Benin river on the coast of southern Nigeria. Between August 1987 and May 1988, a total of five container ships docked in this quiet port, carrying barrels of hazardous wastes entered under an import permit deceptively labeling the cargo as "non-explosive," "non-radioactive," and "non-self-combusting" stuff. Its final destination was a dirt lot in the residential area off Koko's one paved street. An impoverished farmer was paid $100 a month to stack, four high, the old, often dented and rusty barrels. A total of 3,800 tons of waste was dumped in more than 10,000 leaking drums, sacks, and containers at the port of Koko. These contained radioactive materials and a variety of intractable chemicals for which no safe means of disposal exists, including the deadly carcinogenic compound PCB. The containers used were swollen and burst by the desert heat, and the contents were left to seep directly into both the ground and the groundwater supply of the nearby river. Although the biological, human physiological, and ecological consequence of the Koko dumping has yet to be determined, there is no doubt that it will horribly compromise the lives of the local people who continue to scavenge open pits by the dock and to use the empty but deadly storage containers — containers pointlessly marked with the international toxic hazard symbol of skull and crossbones.

Jaar's installation does not offer photographic evidence of the horrendous situation in Koko, Nigeria. The terms of factual research with which he began, the stacks of broken barrels which he saw and photographed, the *in situ* confirmation of the odious conditions quickly evolved into an indignation, at once restrained and seering, that fueled his recent piece, *Geography = War*. Jaar's both most architectural and most theatrical installation to date, this work describes a dark labyrinthine space through which the viewer is impelled to move — physically, mentally or critically and emotionally — past light boxes of images of children playing in Koko's port. The unfolding of the successive images as the viewer walks further into Jaar's maze-like construction produces a dramatic sense of mystery and apprehension. The unfolding theater of *Geography = War* wrests its photographs out of the realm of the static and purely visual, and into the space, our space, of lived social experience. The cryptic, enigmatical environment its artist has fashioned plays upon recurrent Western fantasies of the "voyage" taken into the unknown "dark" continent that is our myth of Africa, a sense of journeying encouraged by at least one light box's projection of the world map at the installation's entrance. Today, Western expansionism has exhausted the wide-open spaces once available for conquering, but the will to colonize remains ingrained in our mindsets, is inextricably involved with our history, and is corroborated by our very bodies as they begin to negotiate as-yet undiscovered territories.

While mentally primed for and seduced into an expedition of sorts, the viewer still encounters none of the usual "travelogue" of religious rituals, of exotic dress, dances, and artifacts — the travelogue in which native subjects are "captured" at a charmingly safe distance within documentary photographs. Jaar refuses to give us the images we have repeatedly used to estrange, mythify, and dehumanize the Other: no ro-

manticizing is possible here, for example, in the harsh bold light of a specific overcast day, amidst the undeniable details of industrial *disjecta*. Inside **Geography = War**'s shadowy, compressed space we are brought face to face with an event and a people we would rather ignore. The barrels of toxic waste are there in the background, almost as a sign; but the emphasis remains on the feisty, confident group of children. Their life-size scale enables us to perceive — to fully apprehend — the features of their faces, faces that, recurring throughout the installation, become if not ever quite familiar, remarkably individual. At the heart of this darkened environment the space suddenly opens out upon an enormous, suffocating image of young people scavenging in an open pit near Koko dock. From the far right margin of the image emerges an imposing, eight-foot figure of a young boy whose audacious presence jars our voyeuristic stance. Undaunted, the boy defiantly occupies the space between us and the background, literally disrupting our visual "command" of the scene. Compositionally he creates an asymmetrical disturbance which posits him as "out-of-place, a threat, an intruder in what is presumably his own land."[47] Face in shadow, he leaps upon us in his imposing size with a vehemence that taps into our worst fears of the unfathomable and recalcitrant Other. Yet the immense scale also possibly assists him to a heroicism, to the monumental authority and importance of which the Other has so long been deprived: such a scale is, at last, a romantic gesture restoring to the boy and to all like him their inborn dignity, power, and humanity. Against the bloodless abstractions of the "Other" and the "Third World" Jaar posits specific, concrete people who exist in specific, concrete ways. To confront them is not so much to learn more about them as to realize *how* we see them or have seen them; it is to make instructively visible the restrictive packagings we have used to collect, define, and ultimately dismiss such "others." At core, the installation's central subject is neither toxic waste nor Africa, but our experience as we contemplate ourselves contemplating other people contemplating us — an experience which, in the artist's words, seeks to close "the extraordinary widening gap between Us and Them, that striking distance that is, after all, only a mental one. This project deals with Us and Them at the very same time because no other alternative seems real enough."[48]

Peters Map

Mercator Map

The map with which Jaar welcomes us to the (Third) world in **Geography = War** might be emblematic of all his artistic efforts. This map, as much as Jaar's images of native people, stands for "the deep, the profoundly perturbed and perturbing question of

our relationship to others — other cultures, other states, other histories, other experiences, traditions, peoples, and destinies."[49] A two-dimensional field of signs that transcribes three-dimensional reality, the map is the preferred (and necessarily inaccurate) tool for apprehending, instantaneously, the world. But as with Jaar's images of others, maps tell us more about ourselves and our methods of structuring, than they do about the universe: we find, not objective reality, but a mirror — a projection — of our own predispositions. Each map is shaped by the sociocultural, historical, and political formulations of its originating epoch. Since 1569, the cartograph most often used to describe the world, and thus determining our vision of it, has been the Mercator, created basically to abet the imperialistic endeavours of European navigators in their discovery, colonization, and exploitation of non-Western climes. By virtue of its long use and institutional authority, this colonial instrument continues to reinforce a worldview with significant consequences for the Westerner and non-Westerner alike — consequences that have nothing to do with objective geographical science. The Mercator map is a transcription that, despite its uniform detail and distribution of emphases, and despite its seeming technical accuracy, is at bottom an agent of imperial domination: a device, in fact, that props up racism by grounding bias in geographical "realities." It does so by giving Western Europe pride of place at the center of the map's image; it does so by distortedly enlarging those areas historically inhabited by white people, and by literally relegating the Third World to a peripheral zone, a narrow fringe of dependency. This world picture is replaced in *Geography = War* by the Peters map, first published in 1974. Objectively less deformed than traditional maps, the Peters projection accurately represents all areas of the world according to relative size. The contrast between these two representations of the earth are shocking. Whereas the Mercator shows the Northern Hemisphere to be far larger than the Southern, the Peters map proves the "North" to actually be half as large as the "South." South America, for example, is in point of fact double the size of Europe, which sits not at the center of the world, but in its northernmost quarter.

Jaar's use of the Peters projection does more than correct cartographic perversions: it posits a world picture and an attendant ideology which forms "part of the revisionist post-colonial effort to reclaim traditions, histories, and cultures from imperialism."[50] The Peters map, an invention of our "postcolonial" epic, no longer geographically represents the Third World as dependent, homogenous, and marginalized. Rather, the underdeveloped nations are shown to be a scattered, heterogenous and variegated aggregate, sharing with the First World an undeniably interdependent yet pluralistically complex destiny. The Peters projection symbolizes, in a sense, the West's loss of clout, of its disproportionately huge scale and world-dominant position; it points as well to the current crisis in Western culture, i.e., to the erosion of a once-inviolate Western (and male) authority in dictating the structures of discourse or the modes of representation. This erosion has become the hot topic not only of geography, but also of anthropology, linguistics, psychology, sociopolitical speculation, and art theory. The loss of a centralized, sovereign subject throws into question the very concept of identity, the certainty of a state, or thought, or thing; it opens the way for the insidious but refreshing appearance of "that secret sharer of present reflection on 'otherness' and 'difference.'"[51] Alfredo Jaar's work is preoccupied with alternative and/or counterdominant positions and locations. Like the Peters projection, a Jaar installation disavows a single point of privilege and a sovereign subject. Admitting no dominant vantage point, Jaar asserts that we are part and parcel of manifold points of view — others' as well as our own. Ultimately, Jaar's work asks us to become aware of where we stand politically on the post- or neocolonial map. What has been our position in global history? How does our frame of mind delimit, circumscribe, and recast that history? In driving toward this new level of questioning, Jaar has found the (re)structuring of representation to be profoundly significant: representation per se is not an abstract or aesthetic issue, but a manifestation of political choices, real, operative, daily political choices. Clearly, then, Jaar's work offers up more than a diverting world "picture." Nothing less than a formative world view is at stake, a world view Jaar would have us, his collaborators or co-producers, at once develop and continuously deconstruct in such a manner as to allow the emerging counternarrative of the Other its full play.

Madeleine Grynsztejn

36

[1] Quoted in Susan Sontag, "Godard," *A Susan Sontag Reader*, introduction by Elizabeth Hardwick (New York: Random House, Inc., 1982), 235.

[2] Quoted in James Clifford, *The Predicament of Culture* (Cambridge, Massachusetts: Harvard University Press, 1988), 215.

[3] Shiva Naipaul, "The Illusion of the Third World," *An Unfinished Journey* (London: Hamish Hamilton Ltd., 1986), 39.

[4] Much information throughout this essay has been drawn from discussions which took place in July 1989 between Alfredo Jaar and the author. I am especially indebted to Prudence Carlson for generously sharing her critical insights on the work in the exhibition as well as for her assiduous editing.

[5] The "Other" is a term which has been used more generally to describe any person or group of people who stand outside of and are "different" from the dominant Western (generally white, male) purview. This would include not only people of the Third World, but also ethnic groups located *inside* the First World (such as American Indians), women, the homeless, the disabled, the insane, among others. The literature on the Other is extensive; for a good introduction, see Tzvetan Todorov, *The Conquest of America* (New York: Harper & Row, Publishers, Inc., 1984).

[6] Naipaul, op. cit., 35.

[7] Norman Gall, "Gold Rush," *Forbes* (July 21, 1984): 172.

[8] Frederick Kiesler's Art of This Century Gallery and Marcel Duchamp's twine installation are discussed in William S. Rubin, *Dada, Surrealism, and their Heritage* (New York: The Museum of Modern Art, 1968), 154, 160.

[9] Brian Wallis, editor, *Hans Haacke: Unfinished Business*, exhibition catalogue, The New Museum of Contemporary Art, New York City (Cambridge, Massachusetts: The M.I.T. Press, 1986), 282-85.

[10] These artists have been described as a group by Eleanor Heartney, "The New Social Sculpture," *Sculpture* (July-August, 1989): 24-29.

[11] Trinh T. Minh-ha, *Woman, Native, Other: Writing Postcoloniality and Feminism* (Bloomington and Indianapolis: Indiana University Press, 1989), 22.

[12] Ibid.

[13] Craig Owens writing on Lothar Baumgarten's work in "Improper Names," *Art in America* (October, 1986): 129. Baumgarten has preceded Jaar in his significant artistic investigations of the Other, specifically the Yanomami Indians with whom he lived for eighteen months (October 1978-March 1980) in the Venezuelan Amazon rain forest.

[14] Minh-ha, op. cit.

[15] Jimmie Durham and Jean Fisher, "The Ground has been Covered," *Artforum* (Summer, 1988): 101.

[16] Ibid., 102.

[17] Anne Rorimer, "Photography-Language-Context," *A Forest of Signs: Art in the Crisis of Representation*, exhibition catalogue, The Museum of Contemporary Art, Los Angeles (Cambridge, Massachusetts: The M.I.T. Press, 1989), 141.

[18] Like any art work, the photograph is as much a creation of the viewer as it is of the photographer or artist. For fully developed theoretical discussions on photography, see Victor Burgin, editor, *Reading Photography* (London: The Macmillan Press Ltd., 1982), and Roland Barthes, *Mythologies* (New York: Hill and Wang, 1972).

[19] See in particular Allan Sekula, "On the Invention of Photographic Meaning," and John Tagg, "The Currency of the Photograph," in Burgin, Ibid., 84-109, 110-41.

[20] Sekula, Ibid., 104-9.

[21] Naipaul, op. cit., 34.

[22] Martha Rosler, "in, around, and afterthoughts (on documentary photography)," *3 Works* (Halifax: The Press of The Nova Scotia College of Art and Design, 1981), 79.

[23] This approach to representing poverty has been explored extensively in film; of particular interest to Jaar is the work of Brazilian filmmaker Glauber Rocha, leader of Brazil's cinema nõvo (new wave) movement and author of "Esthétique de la Faim" (The Aesthetic of Hunger). Deprivation is underscored by "lean" cinematic techniques in other Brazilian filmmakers' works like Nelson Pereira dos Santos' *Vidas Sécas*, 1963. Films by Italian neorealists Roberto Rossellini (*Roma, Città Aperta*, 1945), Luchino Visconti (*Ossessione*, 1943), and Vittorio de Sica (*Ladri di Biciclette*, 1948-49) evince a bleak, impoverished texture, as does Luis Buñuel's *Los Olvidados*, 1950, a film focusing on Mexico City's slum youth.

[24] Susan Sontag, *On Photography* (New York: Dell Publishing Co., Inc., 1977), 12.

[25] Ibid., 4.

[26] Minh-ha, op. cit., 6.

[27] Owens, op. cit., 133.

[28] Earl Shorris, "Raids, Racism, and the INS," *The Nation* (May 8, 1989): 628. Approximately 1.5 million illegal immigrants were apprehended while trying to enter the United States in 1988: it is estimated that for every person detained, two or three have successfully crossed the border. It should be noted that illegal immigrants crossing into the United States are not only from Mexico and Central America, but also from some sixty other countries, including Korea, Turkey, Iran, India, and Brazil. Once loosely organized, illegal immigration of so-called "O.T.M.'s" (other than Mexican) is rapidly becoming a lucrative, professional international industry. An excellent source on illegal immigration is *Mexico and the United States Briefing Session for Journalists*, published annually by the Center for U.S.-Mexican Studies at the University of California, San Diego. My thanks to Elizabeth Sisco for suggesting this reading.

[29] "Illegal Immigrants are Backbone of Economy in States of Southwest," *Wall Street Journal* (May 7, 1985): 1.

[30] For an analysis of the crucial role played by the stereotype in our relationship with others, see Homi K. Bhabha, "The Other Question," *Screen* (November-December, 1983): 18-36.

[31] Caroline Tisdall, *Joseph Beuys* (New York: The Solomon R. Guggenheim Foundation, 1979), 228-35. For an analysis of Beuys' "social sculpture," see Eric Michaud, "The Ends of Art According to Joseph Beuys," *October* (Summer, 1988): 37-46.

[32] Victor Burgin quoted in Anne Rorimer, op. cit., 141.

[33] Ibid.

[34] Kate Linker, "Eluding Definition," *Artforum* (December, 1984): 62. The work of Mary Kelly, Sylvia Kolbowski, and others is discussed more thoroughly in Kate Linker, *Difference: On Representation and Sexuality* (New York: The New Museum of Contemporary Art, 1985).

[35] Ibid.

[36] Craig Owens, "The Discourse of Others: Feminists and Postmodernism," in Hal Foster, editor, *The Anti-Aesthetic: Essays on Postmodern Culture* (Port Townsend, Washington: Bay Press, 1983), 62.

[37] Ibid.

[38] Ibid., 68.

[39] I would like to thank my colleague Greg Kahn for offering this astute observation.

[40] Joseph Kosuth, "1975," *The Fox*, 2: 90-91.

[41] Hans Haacke quoted in Yve-Alain Bois, Douglas Crimp, and Rosalind Krauss, "A Conversation with Hans Haacke," *October* (Fall, 1984): 28. For a comparison of Hans Haacke's work to Minimalism, see Benjamin H. D. Buchloh, "Hans Haacke: Memory and Instrumental Reason," *Art in America* (February, 1988): 104-6.

[42] Certainly, for the most part Jaar's own work is also confined within the autonomous sphere of the art gallery, exposed only to the same, privileged spectator that Minimalist works address.

[43] James Baldwin, *The Fire Next Time* (New York: Dial Press, 1963), 119-20.

[44] For a description of the uses of racism within colonialist enterprises, see Tzvetan Todorov, op. cit., particularly the chapter "Equality or Inequality," 146-67. My thanks to Deborah Small for suggesting this reading.

[45] Minh-ha, op. cit., 80.

[46] In the United States, for example, Congress endorsed an amendment to the Resource Conservation and Recovery Act in 1984 which imposed new regulations that effectively barred the disposal of most toxic materials in landfills, since under these new restrictions the cost incurred in safely disposing of hazardous wastes may be as much as $2,500 a metric ton (the U.S. alone produces between 250 million and 400 million metric tons of hazardous municipal and industrial refuse a year). Waste-broker companies offer Third World nations as little as $3 and up to $40 per ton for received toxic waste, yet this cash amount can sometimes equal the annual national budget of some impoverished countries. The information available on the toxic waste trade is extensive: for a good summary, see Third World Network, "Toxic Waste Dumping in the Third World," *Race & Class*, 30, 3, 1989: 47-56. For information on the Koko dumping grounds, see "Toxic Terrorism," *West Africa* (June 20, 1988): 1108; "Drums of Death," *The African Guardian* (June 20, 1988): 13-20; and "Death Cargo from Pisa," *African Concord* (June 21, 1988): 28-38.

[47] Victor Burgin, "Looking at Photographs," *Reading Photography*, op. cit., 150.

[48] Alfredo Jaar, "La Géographie ça sert, d'abord, à faire la Guerre (Geography = War)," *Contemporanea* (June, 1989): inside cover.

[49] Edward S. Said, "Representing the Colonized: Anthropology's Interlocutors," *Critical Inquiry* (Winter, 1989): 216. This reading was suggested to me by Deborah Small.

[50] Ibid., 219.

[51] Ibid., 225.

Untitled, 1990
billboard
14' x 48'
Mission Gorge Road
San Diego, California
February - March, 1990

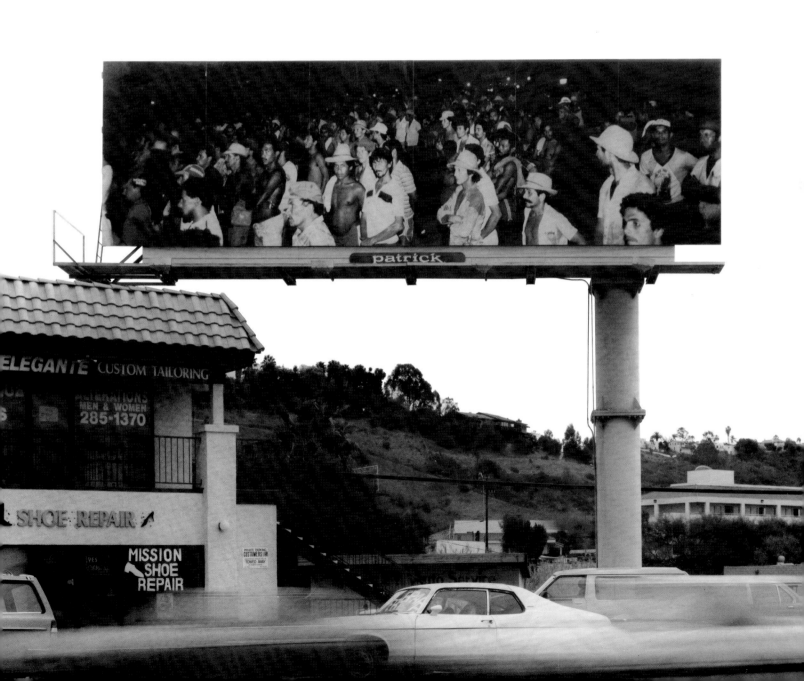

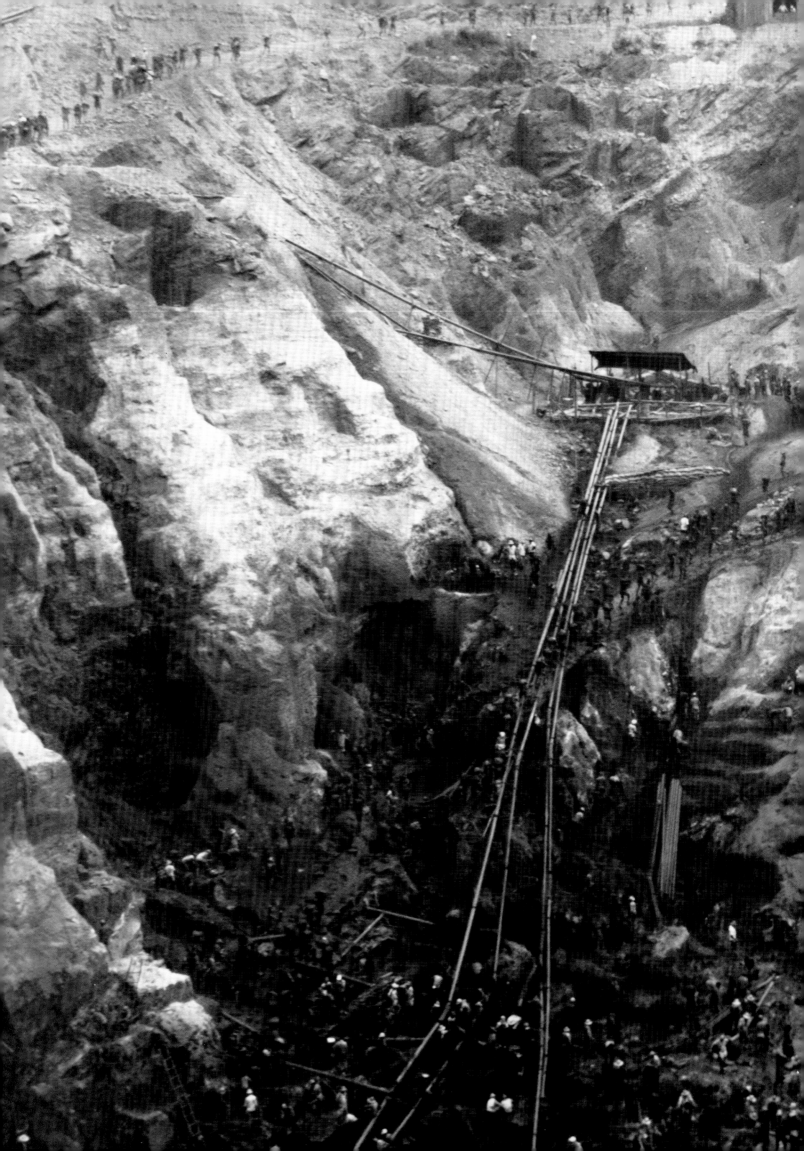

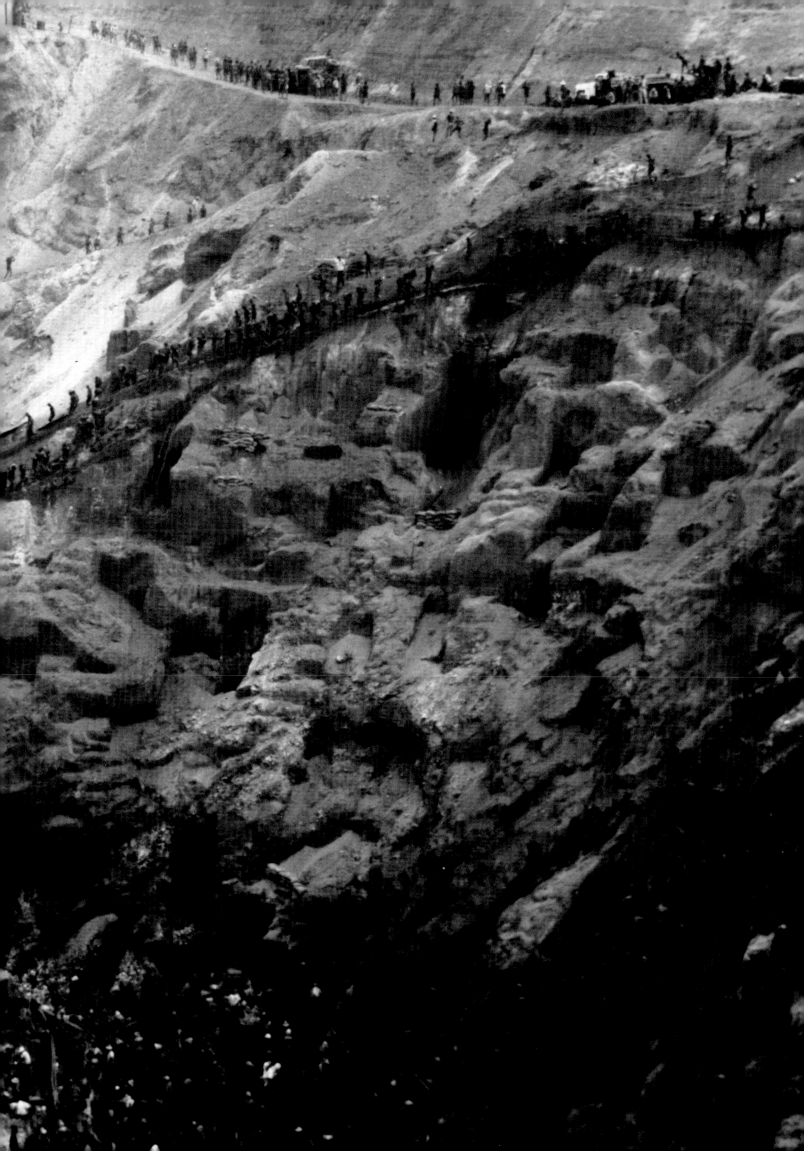

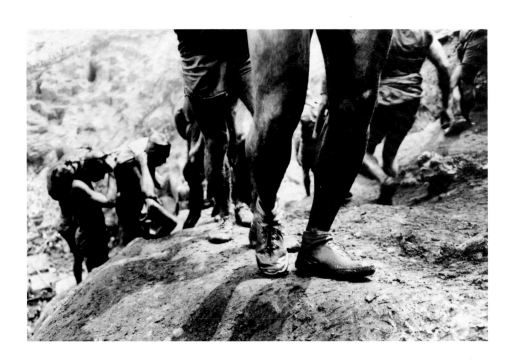

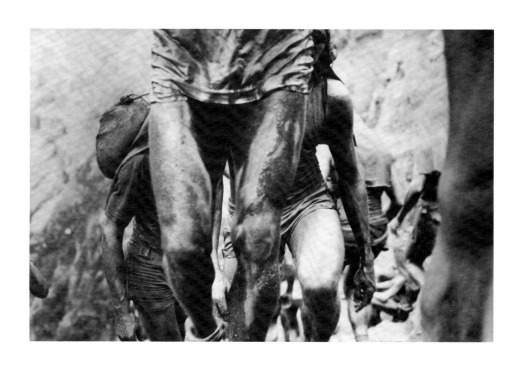

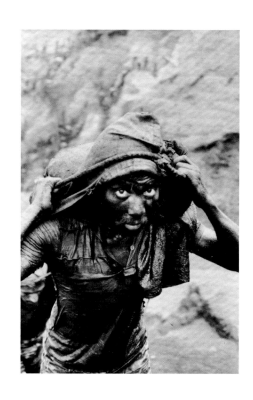

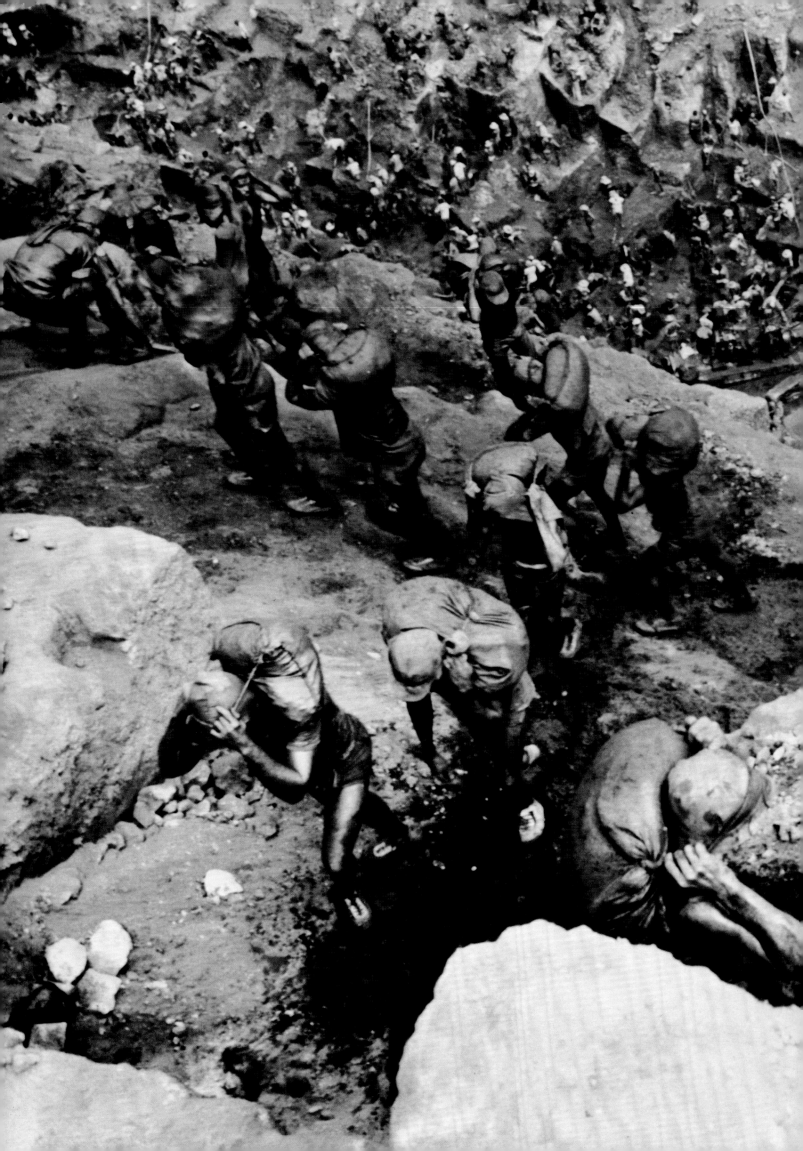

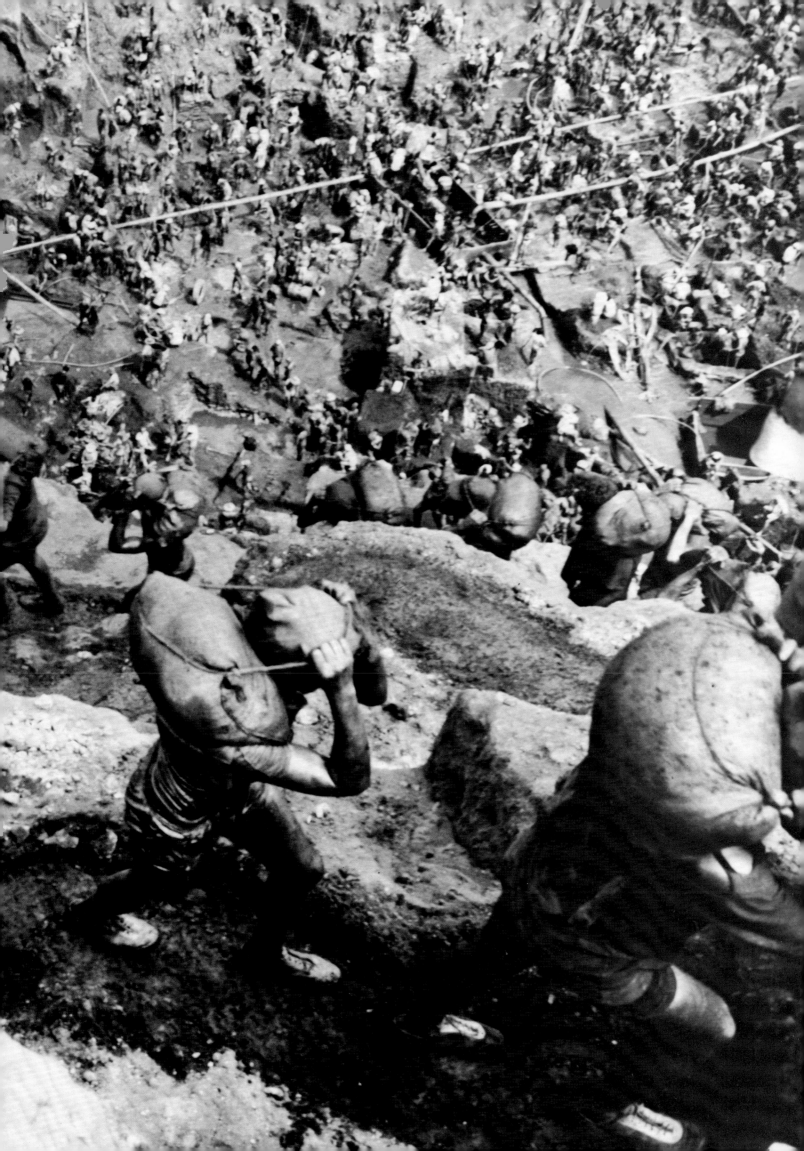

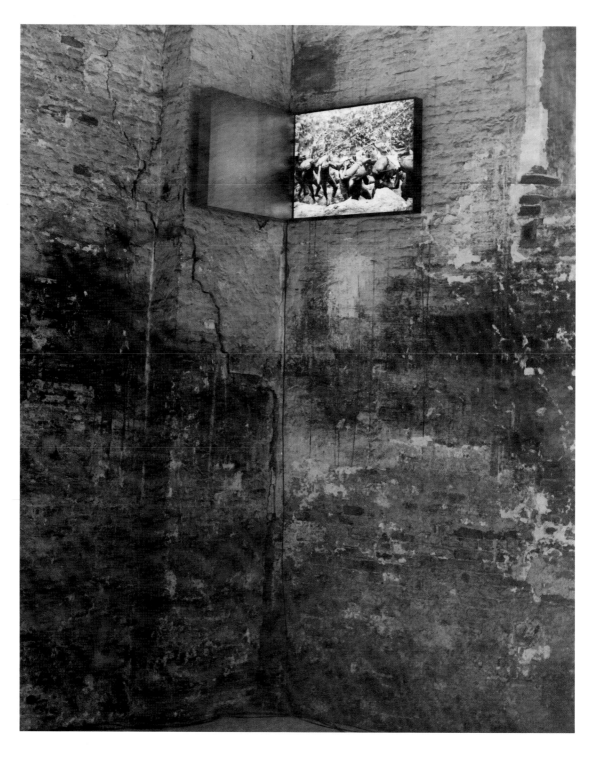

Gold in the Morning, 1986 (detail)

Gold in the Morning, 1986 (detail)

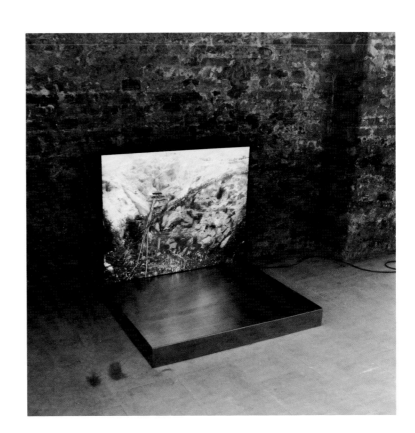

52

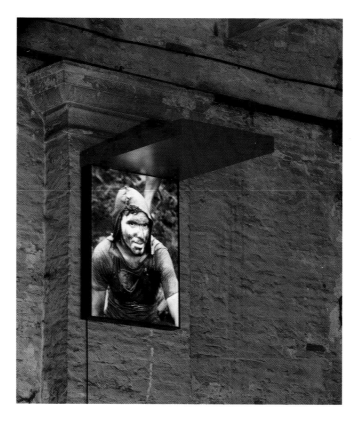

Gold in the Morning, 1986 (detail)

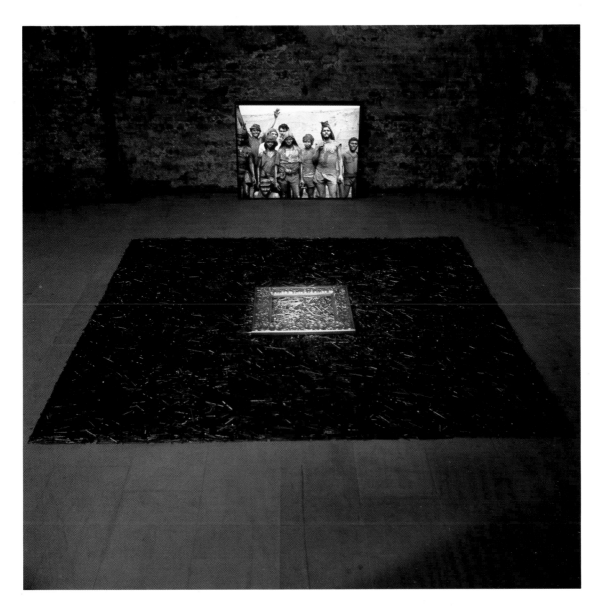

Gold in the Morning, 1986 (detail)

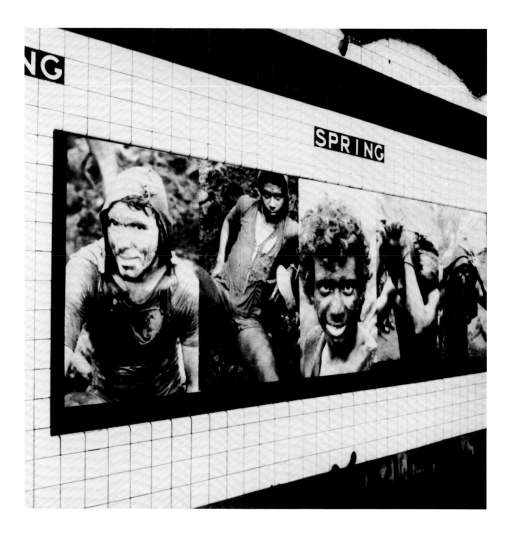

Rushes, 1986-87 (detail)
variable dimensions
installation, Spring Street subway station,
New York City
December 1, 1986 - January 31, 1987

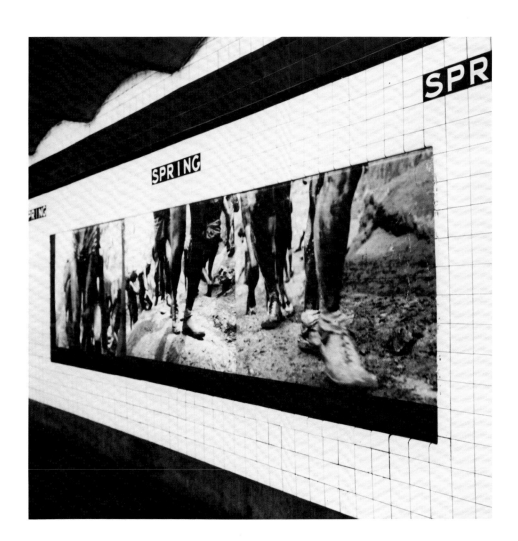

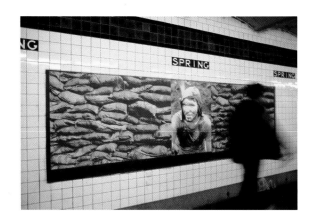

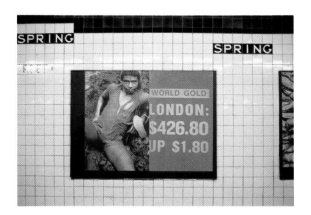

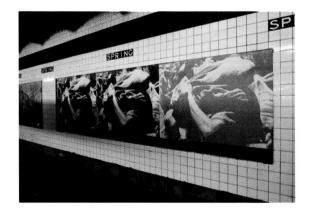

Rushes, 1986-87 (detail)

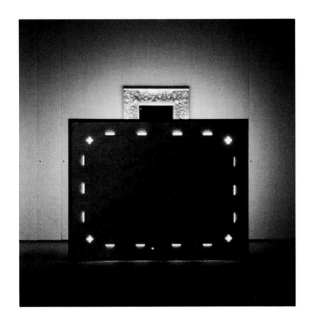

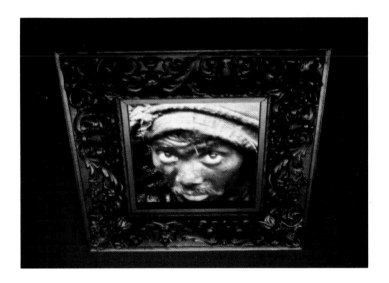

Frame of Mind, 1987
light box with color transparency, mirror,
gilded frame
overall dimension 39" x 40" x 24"
light box, 30" x 40" x 6";
framed mirror, 17" x 17" x 2"
installation, "Frame of Mind," Grey Art Gallery,
New York
January 21 - February 28, 1987
Collection Sherry Remez Wagner
and Ethan J. Wagner

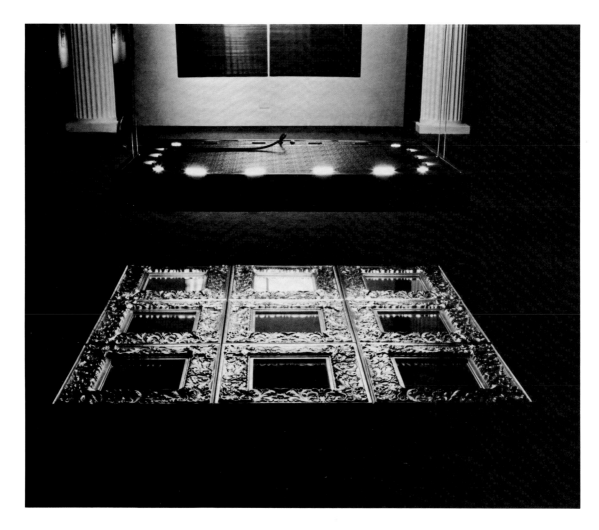

Frame of Mind, 1987
light box with color transparency, mirrors,
gilded frames
overall dimension 48" x 51" x 51"
light box, 30" x 40" x 6";
framed mirrors, 17" x 17" x 2" (9)
installation, "Frame of Mind," Grey Art Gallery,
New York
January 21- February 28, 1987
Collection Lee and Sylvia Terry

Frame of Mind, 1987 (detail)

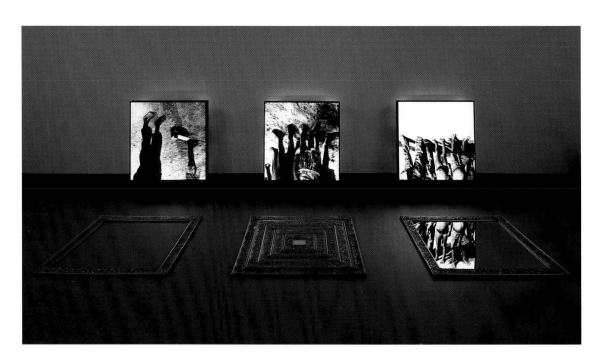

1 + 1 + 1, 1987
light boxes with sepia-toned transparencies,
mirror, gilded frames
overall dimension 50" x 16' x 6'
light boxes, 40" x 40" x 6" (3);
gilded frames, 42" x 42" (3)
Collection Lannan Foundation, Los Angeles

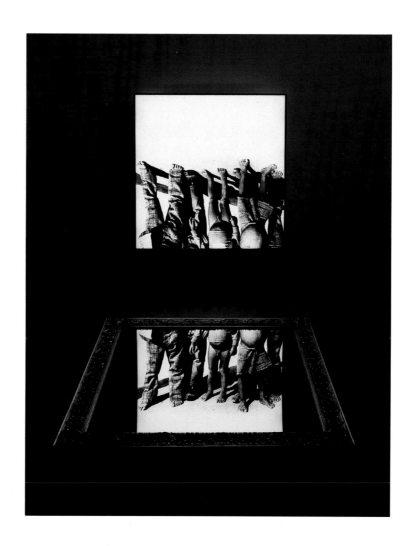

1 + 1 + 1, 1987 (detail)

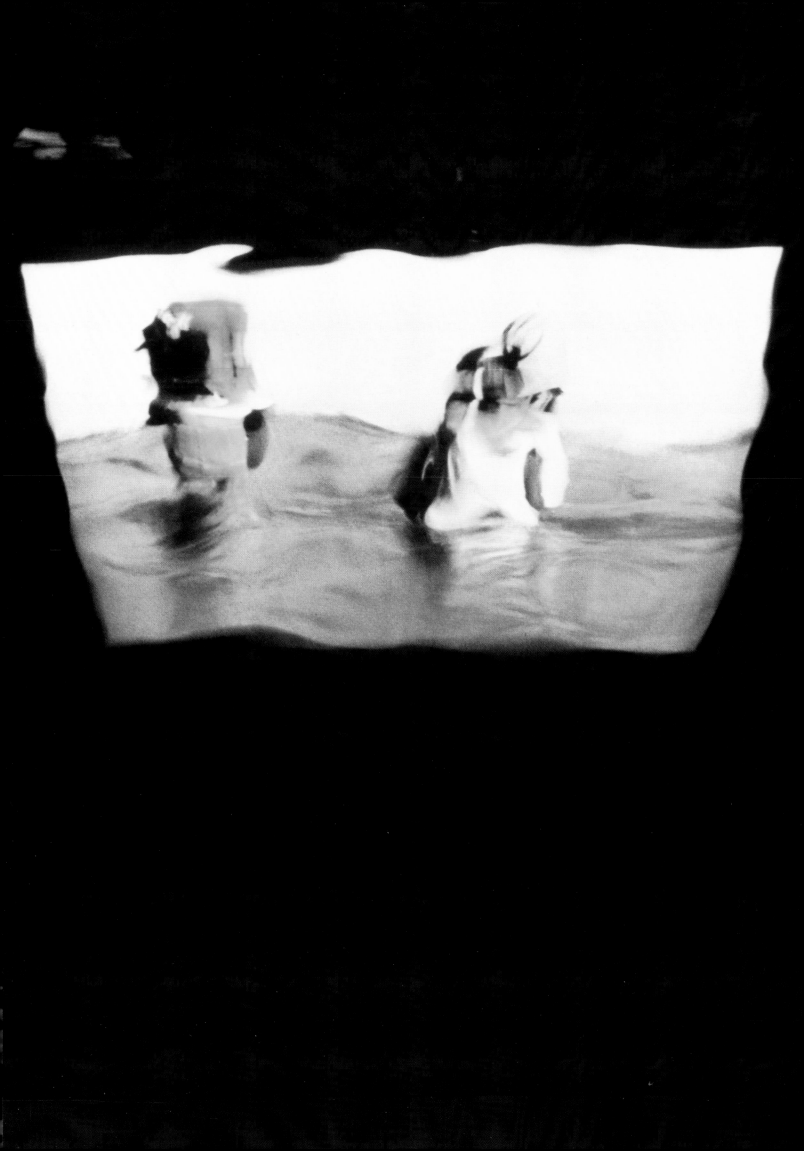

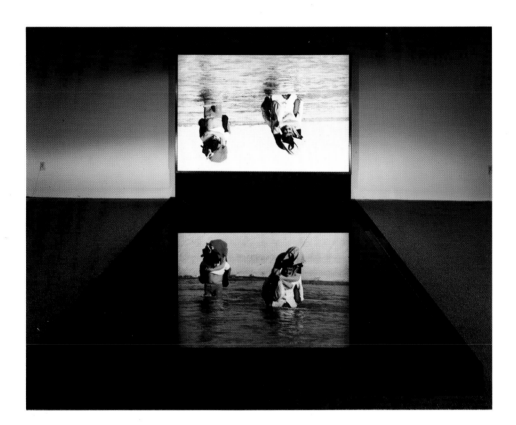

above and left:
Coyote!, 1988
light box with color transparency, pool, water
overall dimension 6' 4" x 8' x 9'
light box, 5' 4" x 8' x 6"; pool, 8' x 8' x 10"
Collection FNAC (Fonds National d' Art
Contemporain), Paris

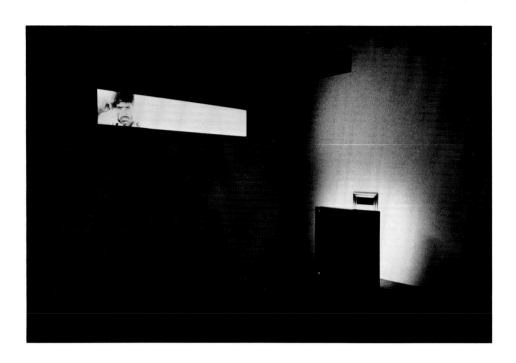

Installation, "Coyote!," 1988
Photographic Resource Center, Boston
March 11 - April 24, 1988

Coyote!, 1988
light box with color transparency, mirror,
gilded frame
overall dimension, 50" x 40" x 24"
light box, 40" x 40" x 6";
gilded frame, 18" x 18" x 2"
Collection Miranda McClintic and Jay Smith

over:
Coyote!, 1988
light box with color transparency
18" x 8' x 7"
Collection Emily Fisher Landau

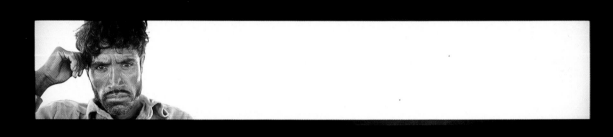

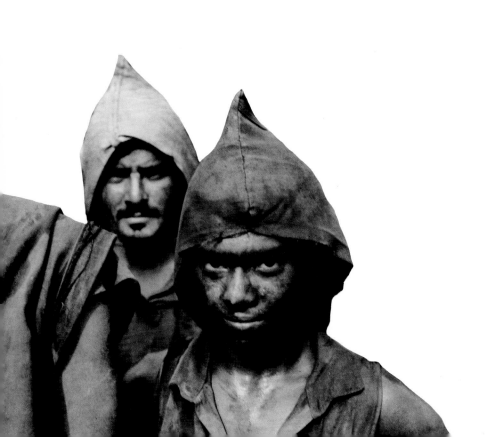

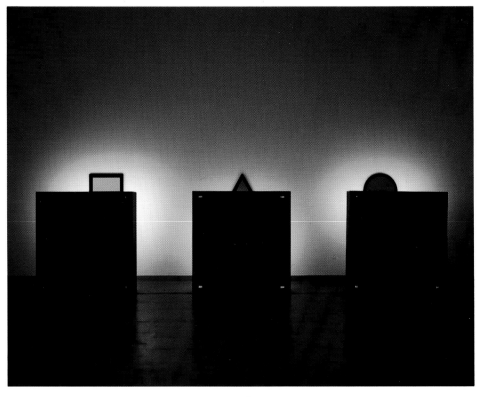

above:
Modernism is Dead, Long Live Modernism, 1988
light boxes with color transparencies, mirrors
overall dimension 50" x 13' 4" x 24"
light boxes, 40" x 40" x 6" (3);
mirrors, overall dimension 18" x 18" x 2" (3)
Collection Emily Fisher Landau

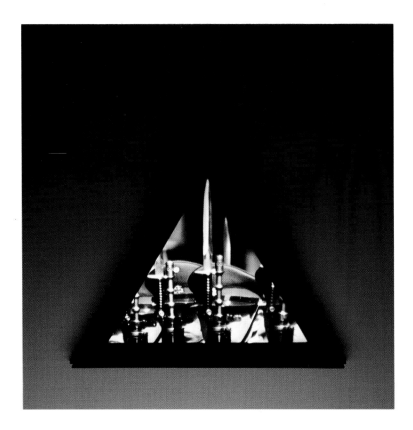

Modernism is Dead, Long Live Modernism, 1988
(detail)

preceding page:
Out of Balance, 1988 (detail)
light box with color transparency, edition of three
18" x 8' x 7"
Collection Marsha Fogel

A Star is Born, 1988
light box with color transparency, edition of three
18" x 8' x 7"
Collection Richard Ekstract

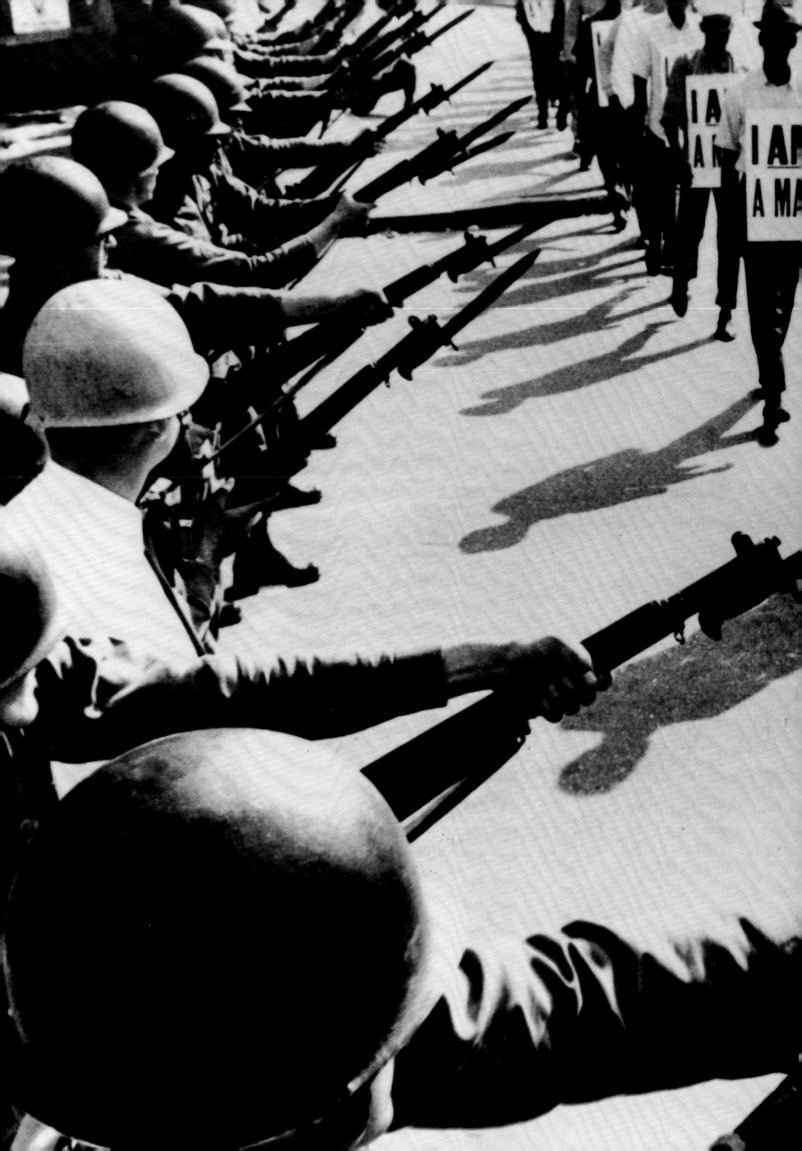

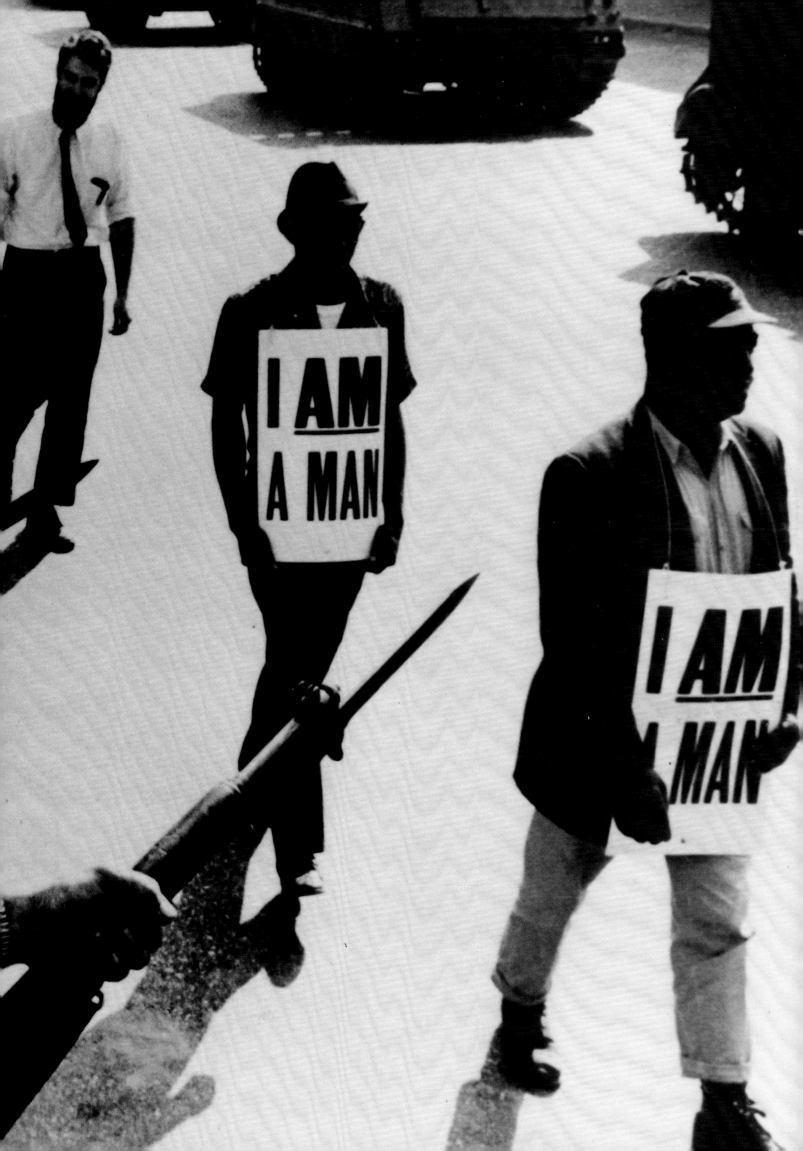

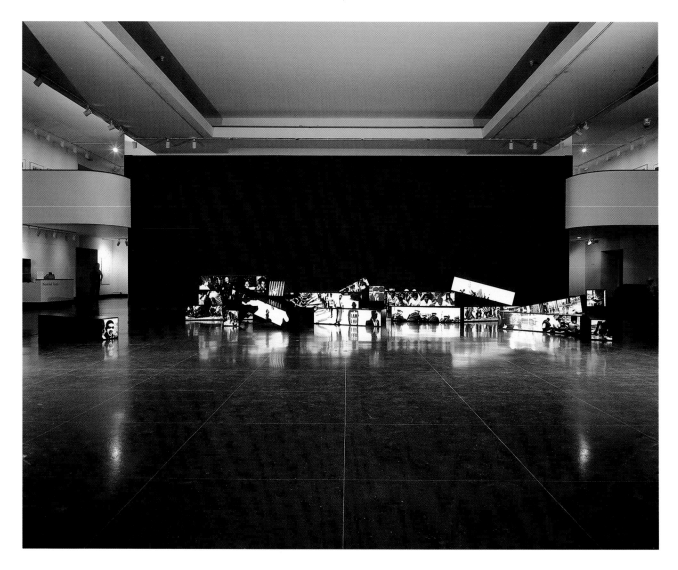

above and right:
The Fire Next Time, 1989
light boxes with black-and-white transparencies
overall dimension 36" x 30' x 10'
light boxes 15" x 15" x 6' (22)
installation, "The Fire Next Time," The Brooklyn
Museum, New York, June 2 - September 4, 1989
Collection High Museum of Art, Atlanta,
Georgia. Purchase with funds from the National
Endowment for the Arts, the 20th Century Art
Acquisition Fund, and funds given by Alfred
Austell Thornton in memory of Leila Austell
Thornton and Albert Edward Thornton, Sr., and
Sarah Miller Venable and William Hoyt Venable

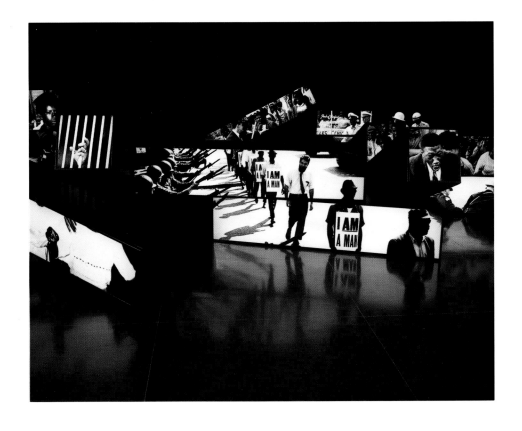

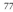

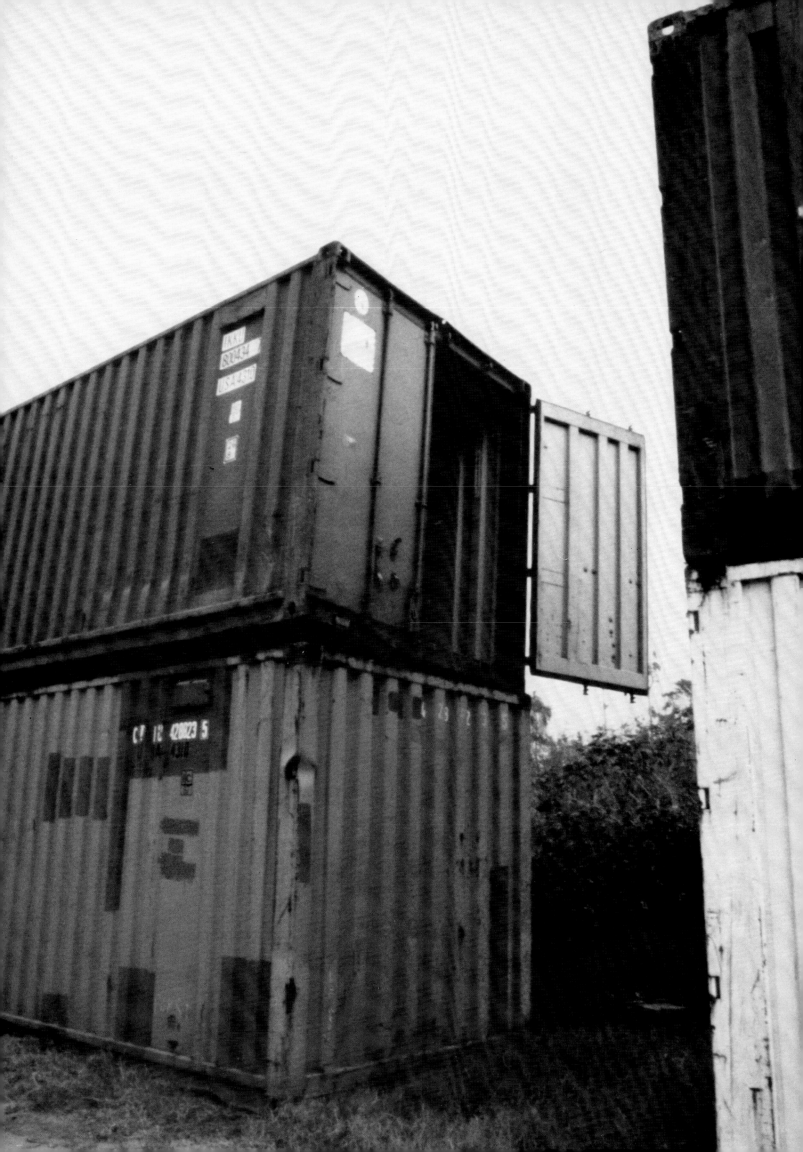

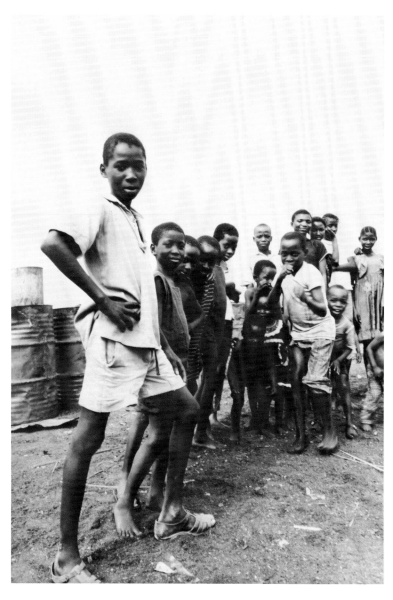

above, right, and over:
La Géographie ça sert, d'abord, à faire la Guerre
(Geography = War), 1989 (detail)
light boxes with color transparencies, mirror
overall dimension 13' x 33' x 40'
light boxes, 30" x 30" x 7"; 40" x 40" x 10";
6' x 48" x 7" (2); 8' x 12' x 10";
framed mirror, 18" x 18" x 2"
Courtesy the artist and Musée National d'Art
Moderne, Centre Georges Pompidou, Paris

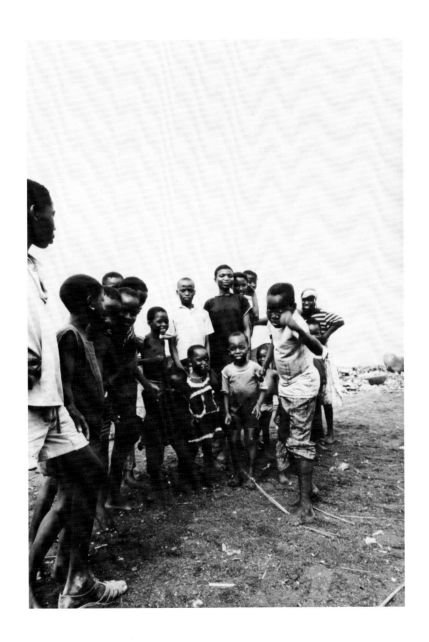

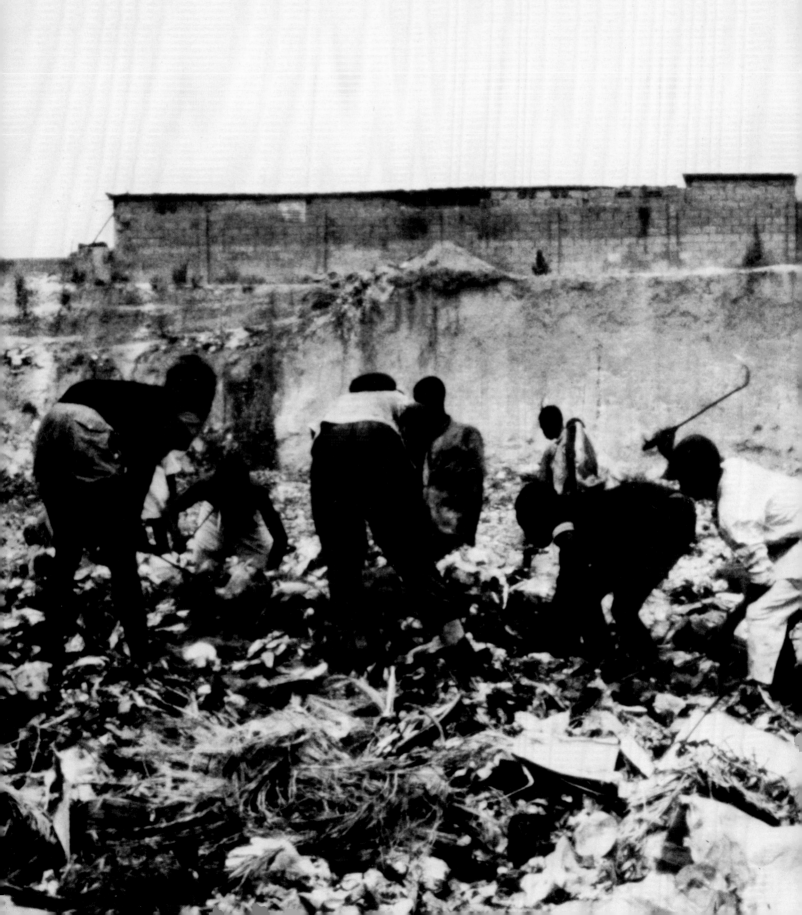

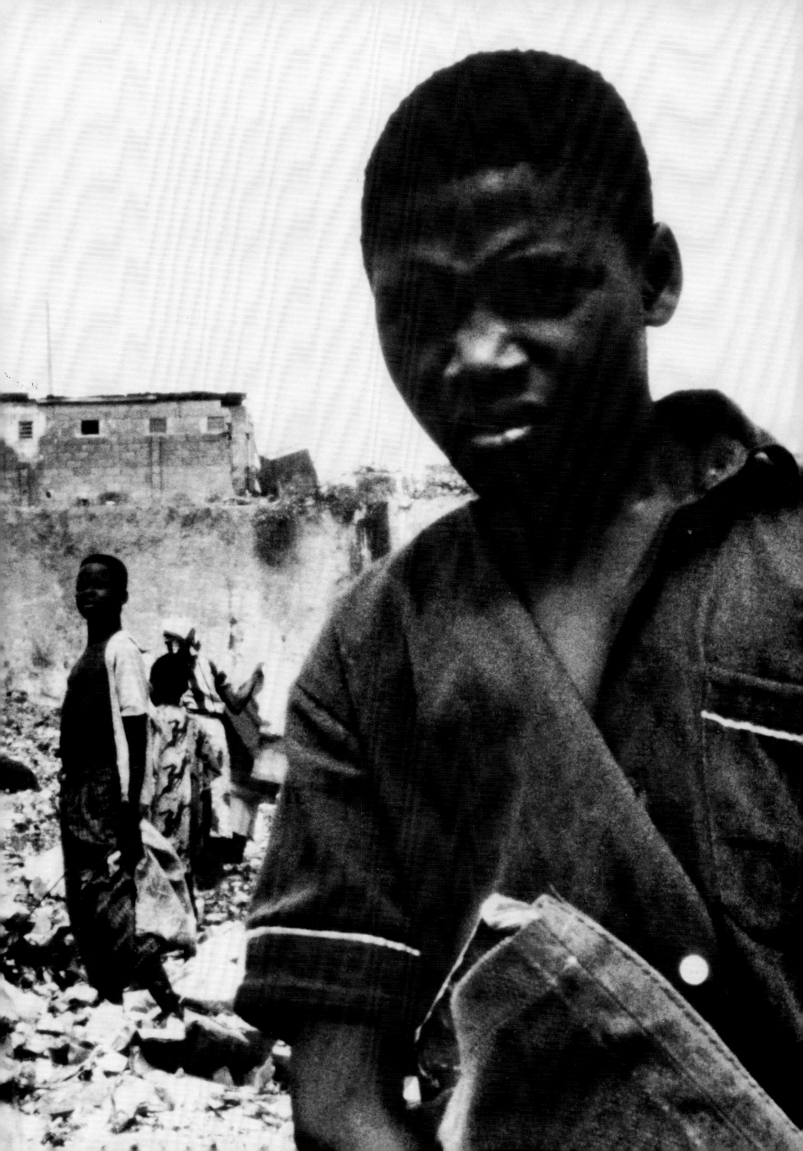

EXHIBITION CHECKLIST

Checklist is as the exhibition appears at the
La Jolla Museum of Contemporary Art. For
each stop on the tour, there will be alterations
in the selection of works.

Height precedes width, width precedes depth

Gold in the Morning, 1986 (rebuilt 1989)
light boxes with color transparencies,
metal boxes, nails, gilded frame
overall dimension approximately 10' x 22' x 22'
light boxes, 30" x 40" x 6" (3);
40" x 30" x 6" (2): metal boxes, 36" x 40" x 6"
(2); 46" x 30" x 6" (2): gilded frame,
25" x 25" x 2": nails, 10' x 10'
Collection La Jolla Museum of Contemporary Art
Museum purchase with funds from the National
Endowment for the Arts, a federal agency
illustrated p. 14, pp. 49-53

1 + 1 + 1, 1987
light boxes with sepia-toned transparencies,
mirror, gilded frames
overall dimension 50" x 16' x 6'
light boxes, 40" x 40" x 6" (3);
gilded frames, 42" x 42" (3)
Collection Lannan Foundation, Los Angeles
illustrated p. 22, pp. 60-61

Frame of Mind, 1987
light box with color transparency, mirrors,
gilded frames
overall dimension 48" x 51" x 51"
light box, 30" x 40" x 6";
framed mirrors, 17" x 17" x 2" (9)
Collection Lee and Sylvia Terry
illustrated pp. 58-59

Frame of Mind, 1987
light box with color transparency, mirror,
gilded frame
overall dimension 39" x 40" x 24"
light box, 30" x 40" x 6";
framed mirror, 17" x 17" x 2"
Collection Sherry Remez Wagner and
Ethan J. Wagner
illustrated p. 57

Frame of Mind, 1987
light box with color transparency, mirror,
gilded frame
overall dimension 39" x 40" x 24"
light box, 30" x 40" x 6";
framed mirror, 17" x 17" x 2"
Collection Sherry Remez Wagner and
Ethan J. Wagner

Coyote!, 1988
light box with color transparency
18" x 8' x 7"
Collection Emily Fisher Landau
illustrated pp. 66, 68

Modernism is Dead, Long Live Modernism, 1988
light boxes with color transparencies, mirrors
overall dimension 50" x 13' 4" x 24"
light boxes, 40" x 40" x 6" (3);
mirrors, overall dimension 18" x 18" x 2" (3)
Collection Emily Fisher Landau
illustrated p. 72

Out of Balance, 1988
light box with color transparency, edition of three
18" x 8' x 7"
Collection Marsha Fogel
illustrated p. 70

A Star is Born, 1988
light box with color transparency, edition of three
18" x 8' x 7"
Collection Richard Ekstract
illustrated p. 73

Untitled, 1988
light box with color transparency, edition of three
18" x 8' x 7"
Collection Milton Fine
illustrated p. 21

Coyote!, 1989
light box with color transparency, pool, water
overall dimension 6' x 5' x 6'
light box, 5' x 5' x 6"; pool, 5' x 5' x 10"
Courtesy The Rivendell Collection

The Fire Next Time, 1989
light boxes with black-and-white transparencies
overall dimension approximately 45" x 30' x 15'
light boxes 15" x 15" x 6' (22)
Collection High Museum of Art, Atlanta, Georgia.
Purchase with funds from the National Endow-
ment for the Arts, the 20th Century Art
Acquisition Fund, and funds given by Alfred
Austell Thornton in memory of Leila Austell
Thornton and Albert Edward Thornton, Sr., and
Sarah Miller Venable and William Hoyt Venable
illustrated pp. 74-77

Out of Balance, 1989
light box with color transparency, edition of three
18" x 8' x 7"
Courtesy the artist and Diane Brown Gallery,
New York

Out of Balance, 1989
light box with color transparency, edition of three
18" x 8' x 7"
Courtesy the artist and Diane Brown Gallery,
New York

Untitled, 1990
billboard
14' x 48'
Courtesy the artist
illustrated p. 39